confirmed by lighting green in the viewfinder. If you keep the shutter-release button partially depressed, it's possible to recompose your photograph without the focus or exposure altering. If focus cannot be confirmed, ● will blink and you will not be able to fire the shutter. Pressing the shutter-release button down fully will expose your image.

AI Servo AF is suited to sports/action or wildlife photography, as it's designed to track your subject's movements and maintain focus. AI Servo AF is arguably most effective when using **Auto selection: 65 pt AF** (see page 44). The manually selected focus point is used initially, but as long as you hold the shutter-release button down halfway, focusing will automatically switch to one of the other points as movement is tracked (providing your subject remains within the focus point area). Focus is not locked until you press the shutter-release button down fully. Unlike One-Shot AF, ● does not light in the viewfinder to confirm focus.

AI Focus AF is a hybrid of One-Shot AF and AI Servo AF. AI Focus AF begins focusing in a similar manner to One-Shot AF mode, but switches to AI Servo AF if your subject subsequently begins to move (the camera will continue to track the

subje(
releas
When focus has switched to AI Servo AF the beeper will continuously sound very softly as focus is tracked.

Although AI Focus AF sounds like a good compromise between One-Shot and AI Servo, in practice it is marginally slower to start tracking movement than AI Servo, so if you are certain your subject will move, it is better to use AI Servo instead.

> **Notes:**
> The AF mode and AF point selection is selected automatically when the camera is set to 🄰⁺.
>
> If **Beep** is set to **Enable** on the 🄰 1 menu, the EOS 7D Mark II will beep to confirm focus in One-Shot AF mode.
>
> If you press the AF-ON button, the camera will focus without you needing to press halfway down on the shutter-release button.
>
> In One-Shot AF mode the exposure will be locked at the same time as the focus.

The EOS 7D Mark II has 65 AF points arrayed across the viewfinder in a long rectangle. When the camera focuses, at least one of these points is used to determine the camera-to-subject distance and focus the lens. All of the AF points are "cross type," which means they can detect both vertical and horizontal lines. This makes focusing accurate even in low light or when you are using a lens with a maximum aperture of f/5.6.

However, the central AF point has diagonal sensors as well, which are active when used with an f/2.8 lens. This makes it by far the most effective of the AF points. The central AF point switches to cross-type focusing when used with lenses with a maximum aperture of f/8 or when used in ambient lighting equivalent to -3EV (such as a moonlit scene). If the other AF points start to struggle to lock focus, switching to the central AF point can often help.

The AF points can either be grouped together in "zones" or selected individually. Individual AF-point selection is more suited to static subjects, such as landscape or still life images. As the AF points cover a large area of the viewfinder, you have very fine control over where the camera focuses.

Conversely, zone selection is better suited to moving subjects, where fine control needs to give way to a broader spread of focus point options.

Selecting the AF Area Selection mode and moving the AF point/zone

1) In shooting mode, press ⊡. Look through the viewfinder (or on the rear LCD screen) and either repeatedly pull the 🗘 down or press the M-Fn button until you reach the desired AF Area Selection mode.

2) While still looking through the viewfinder or LCD, use ✵ to move the AF point/zone around the AF frame area.

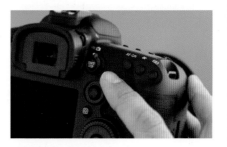

AF MODE SELECTION ⌃
The EOS 7D Mark II's new AF area selection lever is a valuable addition to the camera, making AF area selection more intuitive.

> **Note:**
> If you import a Raw file into the Digital Photo Professional (DPP) software provided with your EOS 7D Mark II, you can display an overlay that shows you the AF point(s) that were used to achieve focus.

› Manual select.: Spot AF

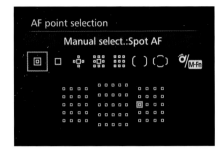

› Manual selection: 1pt AF

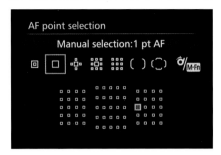

This mode restricts you to a single manually selected AF point, and is superficially similar to **Manual selection: 1pt AF** described at the right. However, the AF point used here is far smaller than in **Manual selection: 1pt AF** and therefore it has to be placed far more precisely to achieve sharp focus (the focus area is the smaller box inside the main, manually selected AF point).

Manual select.: Spot AF is most useful when you have a subject that is surrounded by other elements in the scene and you want to be able to focus precisely on your subject. However, because the AF area is so small, there's an increased likelihood that area will be lacking in the detail necessary to achieve sharp focus. If the AF begins to hunt in this mode switch to **Manual selection: 1pt AF**.

As with **Manual select.: Spot AF,** this mode restricts you to a single, manually selected AF point. Although the AF point isn't as fine as that selected by **Manual select.: Spot AF**, the ability to move the AF point around the viewfinder makes this mode ideal for off-center subjects, or when you need to focus on one specific element in the scene. A good example is when shooting portraits and you want to focus on your subject's eye—the focus point could be moved precisely to the eye to make sure it is pin-sharp.

› Expand AF area: ⬚

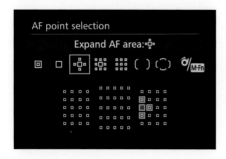

› Expand AF area: Surround

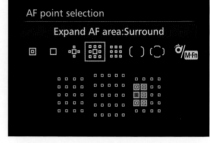

Expand AF area: ⬚ also lets you choose a single AF point ☐, but the surrounding focus points ◙ also have an influence and can be used to aid the selected AF point. If you're shooting a moving subject, this mode will help the EOS 7D Mark II's AF system keep track of the direction of the movement more easily.

Expand AF area: Surround is similar in principle to **Expand AF area:** ⬚, but with a greater number of surrounding AF points used. Think of this mode as being like having a large single AF point. This is most useful for moving subjects that would be difficult to track with a single AF point.

› Manual select.: Zone AF

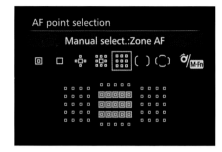

› Manual select.: Large Zone AF

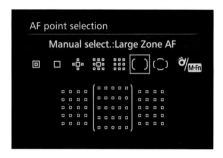

In this mode, the AF area is divided into nine zones, and all of the AF points in the selected zone are used for focusing. In use, the EOS 7D Mark II will focus on the nearest point in the scene to the camera in the selected zone.

As each zone is effectively acting as a very large AF point, it can be difficult to focus precisely on one particular subject (particularly if there's something in between the camera and your subject). However, it is useful for shooting action images, especially when you are confident that your subject will enter the selected zone and will also be the closest element in the image.

In this mode, the AF area is divided into three selectable zones (left, center, and right). As with **Manual select.: Zone AF**, all of the AF points in a zone are used for focusing, with the camera focusing on the nearest point in the scene that is within the selected zone.

› Auto selection: 65 pt AF

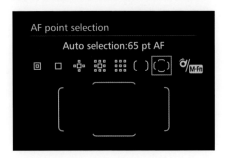

Set to this mode, the EOS 7D Mark II uses all of the AF points to determine focus. Focus is usually set to the nearest point in the image that provides enough detail for the focusing system.

When One-Shot AF is used, the AF point(s) that achieve focus will light up in the viewfinder. When AI Servo AF is selected, the first manually selected AF point will be used to begin focusing. Focusing will then switch to the other points automatically as the subject's movement is tracked.

› Live View AF

When you switch to Live View, your choice of AF modes is simplified to just three. AF is also slower than using the viewfinder—you wouldn't use Live View for sports/action photography, for example. However, the performance is still respectable, thanks to the camera's Dual Pixel CMOS AF.

The focusing mode in Live View can be altered either by pressing **Q** and selecting the required AF mode, or by pressing MENU and selecting **AF method** on ◙ 5.

⌣̇ + Tracking is the default setting for Live View AF. As the name suggests, it's designed for shooting portraits. If your portrait subject moves, their face will be tracked. When activated, the camera will automatically detect a face and draw a white focus frame ⌐ ⌐ around it. If there are a number of faces in the shot the focus frame will change to { }.

Use ✷ to move the frame to the target face and press the shutter-release button down halfway to focus. Once focus has been achieved, the target box will turn green as confirmation. Press the shutter-release button down fully to take the shot. If focus cannot be achieved, the target box will turn orange; if no faces are detected, the focus mode will switch automatically to **FlexiZone AF ()**.

FlexiZone **AF()** divides the frame into 31 AF points that are automatically selected by the camera, or nine large AF zones that can be chosen manually (the default setting is automatic selection).

When focus is achieved after pressing down on the shutter-release button, the active AF points are shown as green boxes. To switch between automatic point selection and zone selection press ⓢⒺⓉ.

Zone selection allows you to choose which area of the image is used. To jump between the nine zones use ✻, or press ⓢⒺⓉ to move the active AF point to the center of the frame.

FlexiZone **AF▢** is the simplest of the three AF modes. Here, the AF point (shown as a white box) will initially be set at the center of the screen. You can move the AF point around using ✻, and press down halfway on the shutter-release button to focus at that point (pressing ⓢⒺⓉ will re-center the AF point).

The AF point will turn green when focus is achieved. If focus cannot be confirmed, the AF point will turn orange, at which point you will need to move the AF point and try again.

FLEXIZONE
Select an AF zone according to where you expect your subject to be.

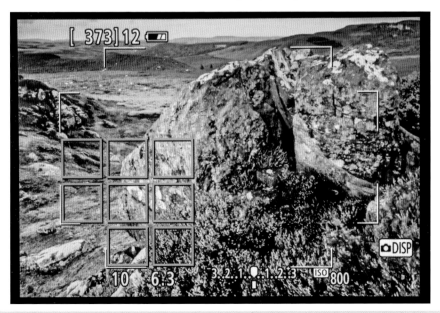

» EXPOSURE

In order to achieve a correctly exposed image, your EOS 7D Mark II has to measure the amount of light reflected by the scene back toward the camera. The way this information is interpreted and how this affects the final exposure is determined by the metering mode you select. You can also override the meter's recommended exposure or lock the exposure so that it isn't affected by any changes you make to the composition or in the scene itself.

› Metering modes

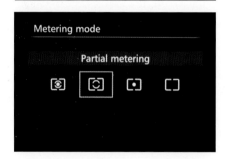

There are four different metering modes that can be selected on the EOS 7D Mark II. These metering modes can be selected either from the Q screen, or by pressing the WB-◉ button.

Evaluative metering ◉ is the default metering method, which works by splitting the image into 252 separate zones. Each zone is metered individually and the

exposure is calculated by combining the results—with the EOS 7D Mark II making an intelligent guess about the type of scene you're photographing. The camera also takes into account where the focus point is. This system is very accurate and can generally cope, even with unusual lighting situations.

Partial metering ◙ and spot metering ◉ don't meter the entire image, just the central 6% and 1.8% of the center of the image frame respectively. These two modes are most useful when you want to set the metering for a specific area of the image.

Center-weighted average metering ☐ has largely been superseded by ◉. As with ◉, all 252 metering zones are used to assess the exposure, but ☐ biases the exposure heavily toward the center of the frame. The one advantage that ☐ has over ◉ is that it is arguably more consistent and easier to predict the results. However, ☐ isn't ideal when you're using filters, such as ND graduates.

Notes:
The metering mode is set to ◉ in Ⓐ⁺ mode.

The exposure is not set until the shutter-release button is fully depressed when using ◙, ☐, and ◉ metering.

› Exposure compensation

Exposure compensation allows you to override the camera's suggested exposure in **P**, **Tv**, and **Av** modes in ½- or ⅓-stop increments, up to ±5 stops. This means you can compensate for any exposure errors the camera may make or adjust the exposure for creative effect.

There's a choice of how to set exposure compensation. The simplest method is to turn ⊙ after pressing down halfway on the shutter-release button to activate the camera's metering. Turn ⊙ counter-clockwise to apply negative compensation (making the final image darker) or turn it clockwise to apply positive compensation (making the final image lighter).

Exposure compensation can also be set pressing Ⓠ, highlighting **Exposure comp./AEB setting**, and turning ⊙.

Finally, you can also alter exposure compensation (and AEB) via the 📷 2 menu screen.

› Auto exposure bracketing

Bracketing is the term used when you shoot several images at different settings. The first shot is usually "correct," and the other shots are variations on the settings used to make the first shot. Auto exposure bracketing (AEB) creates a sequence of shots using different exposure settings. This is arguably more useful when shooting JPEGs, rather than Raw files, as there is more scope for exposure adjustment in postproduction with the latter.

The EOS 7D Mark II's default bracketing sequence is three frames at up to ±3 stops lower or higher than the first image. AEB can be set by pressing Ⓠ, highlighting **Exposure comp./AEB setting**, and then turning ≋. Turn ≋ to the right and the difference in the exposure of the sequence is increased; turning ≋ to the left will decrease the difference.

COMPENSATION »
A more detailed exposure compensation/bracketing screen can be found on the 📷 2 menu, or by selecting **Exposure comp./AEB setting** on the Ⓠ screen.

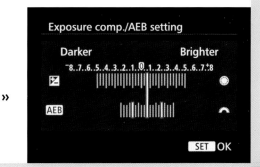

THE EXPANDED GUIDE

47

In One-Shot AF mode, holding the shutter-release button down halfway locks the exposure. It also locks focus. However, there are times when it's beneficial to lock exposure only. Good examples of when this may be necessary are when you have a spot-lit off-center subject against a dark background or when the tonal range of the scene constantly changes, causing the meter reading to fluctuate.

As with most photography problems, Canon has devised a solution: ✳ AE lock. Activating AE lock freezes the meter reading so that it doesn't change. This allows you to recompose your shot without the exposure values altering, so you don't have to worry that an incorrect exposure may occur because the tonal range of the scene has changed.

Activating AE lock

1) Press the shutter-release button down halfway to activate the exposure meter in the camera.

2) Press ✳. ✳ will light in the viewfinder, or if you are using Live View, it will be displayed on the LCD to show that AE lock has been activated.

3) Recompose and press the shutter-release button down fully to take the shot.

4) AE lock is cancelled after you've taken the shot. If you want to keep exposure locked, hold down ✳ as you shoot.

> ***Notes:***
> AE lock is applied to the center AF point if the lens is set to MF.
>
> You cannot set AE lock if you're using Ⓐ or **B**.

Metering mode	AF point selection method	
	Automatic	**Manual**
⊡	Exposure is determined and locked at the AF point that achieved focus.	Exposure is determined and locked at the selected AF point.
⊙/▢/⊙	Exposure is determined and locked by the central AF point.	

» WAVES

Tidal water is a good example of the sort of scene where tonal values constantly shift, causing the meter reading to fluctuate. For this shot I used the spot meter to meter from the rocks and then locked the exposure before a wave crashed over them.

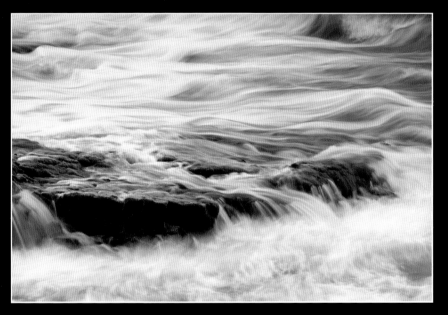

Settings
> Focal length: 18mm
> Aperture: f/16
> Shutter speed: 1/3 sec.
> ISO: 200

› Histograms

The EOS 7D Mark II has the facility to display an image histogram during Live View and after shooting in playback. The histogram is a very useful tool that helps you assess an image's exposure.

A histogram is a graph showing the distribution of tones in an image. The left edge of a histogram represents pure black; the left half shows the range of tones in an image that are darker than mid-gray; the right half shows the range of tones in an image that are lighter than mid-gray; and white is at the extreme right edge. The vertical axis shows the number of pixels in an image of a particular tone.

If a histogram is skewed to the left, this may be an indication that the image is underexposed, or you are shooting a naturally dark-toned subject. If the histogram is skewed to the right, the image may be overexposed, or you are shooting subjects that are naturally light in tone.

Using a histogram requires you to think about the tonal range of the scene being shot and the shape that the resulting histogram should be. However, if a histogram is very definitely squashed against either the left or right edge it has been "clipped." This means there are pure black or pure white pixels in the image (depending on which end of the histogram is clipped)—there is no usable image data in those pixels.

LUMINANCE ⌄

The EOS 7D Mark II can display a luminance histogram and an RGB histogram. A luminance histogram (the type shown here) is easier to read, as it shows the range of tones in the image as though the image had been converted to grayscale. RGB histograms are useful if you want to judge whether the red, green, and blue channels in an image are clipped.

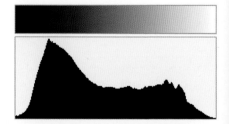

» ISO

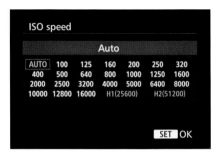

The shutter speed and aperture physically control how much light reaches the sensor, but the third corner of the exposure triangle—ISO—determines how much light is necessary to make a successful image to start with. The higher the ISO you set, the more sensitive the sensor is to light. This means you can use a faster shutter speed and/or a smaller aperture than would otherwise be possible due to the ambient lighting conditions.

› Noise

There's a price to pay when increasing the ISO value: noise. Image noise is seen as a reduction in fine detail and an increase in "grittiness" in the image—the higher the ISO, the greater the level of noise.

In terms of image quality, the optimal ISO setting for a digital sensor is the lowest setting available. On the EOS 7D Mark II this is ISO 100. That said, there is no reason not to use higher ISO settings, particularly if you're handholding the camera. Image noise can be removed either in-camera or during postproduction. Camera shake (caused by the camera moving during an exposure) is less easy to disguise.

There are two types of noise: luminance and chroma. Luminance noise is arguably the least objectionable, as it resembles film grain in structure. Chroma noise is seen as random blotches of false color and is more difficult to remove or mitigate successfully.

Another problem with increasing ISO is that color fidelity and dynamic range are decreased. The latter problem means that you may find it more difficult to retain detail in the shadows at higher ISOs. There's also less scope for exposure adjustments in postproduction when a high ISO is used (at least not without a serious compromise to image quality). Therefore, the higher the ISO you use, the more exact your exposure needs to be.

> ### Tips
>
> *Don't use Auto ISO if you are using neutral density (ND) filters.*
>
> *Image noise is more easily seen in areas of even tone (such as the sky). If using a high ISO setting, avoid including large areas of even tone.*

The EOS 7D Mark II offers you the choice of either selecting a specific ISO value or letting the camera choose an ISO automatically depending on the lighting conditions. Setting a fixed ISO value is most useful when the lighting intensity is consistent or you're using a tripod. Auto ISO is ideal when you're shooting in fluctuating lighting conditions or when the ambient lighting is low and you need to handhold your camera.

There are several ways to set the ISO. The first is to press the ⚡/ISO button and turn ⚙. This allows you to quickly change the ISO using the top LCD panel (or on the rear LCD in Live View). ISO can also be set using Q.

There is also a number of options to fine tune the ISO via the **ISO speed settings** screen on the 📷 2 menu. The standard ISO range on the EOS 7D Mark II is ISO 100 to 16,000, adjustable in ⅓-stop increments. However, you can expand the ISO range to use H1 (equivalent to ISO 25,600) and H2 (equivalent to ISO 51,200). See chapter 3 for details.

Images taken with the EOS 7D Mark II are relatively noise-free from ISO 100–1600, although luminance noise increases visibly from ISO 3200–12,800. However, this can be reduced using in-camera noise reduction or later in postproduction. Noise is heavy when using H1 and H2, with luminance noise smothering fine detail and chroma noise reducing color fidelity.

NOISE ⌃
The higher the ISO setting, the more noise increases. The images on the opposite page are close-up details of the area in red, showing the effect of using different ISO settings.

Notes:
Noise is most visible on screen when an image is viewed at 100% magnification. However, when you reduce the resolution of an image, noise becomes less visible. Using a higher ISO setting is therefore less of an issue if you know that the image will be reduced in size later.

The ISO is set automatically when shooting in A⁺ mode.

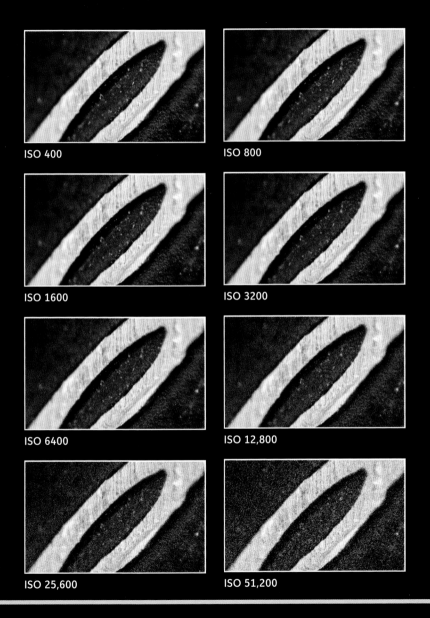

ISO 400

ISO 800

ISO 1600

ISO 3200

ISO 6400

ISO 12,800

ISO 25,600

ISO 51,200

By default, your EOS 7D Mark II will automatically display the image you've just shot as soon as you take your finger off the shutter-release button. The length of time the image is initially displayed for can be changed on the ⬛ 1 menu by altering the Image review time settings.

To view other still images or movies after shooting, press ▶. The last still image or movie viewed will be displayed on the rear LCD screen (a movie is distinguished by a **SET** 🎬 icon at the top left of the screen). You can skip backward through your still images and movies by turning ⟳ counterclockwise, or forward by turning ⟳ clockwise (you can also turn 🎛 to skip through images using the method set for Image jump w/🎛 on the ▶ 2 menu).

Pressing **INFO.** repeatedly toggles between three different ways of viewing still images and movies. The default is a simple display showing only the still image or the first frame of the movie. The second option shows the still image or movie with a restricted amount of shooting information. The third screen shows detailed information initially with a brightness histogram. When this detailed information screen is displayed, pressing ▲ / ▼ switches between a panel showing the lens information/histogram, white balance, Picture Style, color space/ noise reduction, lens aberration correction, or GPS settings (if GPS was active at the time of shooting).

› Playback Quick Control

If you press **Q** during playback, you can set the following functions: Protect images ⊶ (see page 58); Rotate 🔄; Rating ★; Raw to JPEG conversion 🔄 (when viewing RAW files only); Resize (when viewing JPEG files only) 🗗; Highlight alert; AF point display; or Jump method 🔀. Options in gray are not available when viewing movies.

› Magnifying images

› Image index

Still images (not movies) can be magnified in playback between 1.5x and 10x. This is a very useful way of checking focus after shooting, especially when creating macro images or if a large aperture has been used and depth of field is minimized.

Magnify images
1) In single image playback mode press \mathcal{Q}.

2) Turn ⌛ clockwise to zoom into your image (turn counterclockwise to zoom back out again). The degree of magnification and the area currently displayed is represented by a white box within a small gray box at the bottom right corner of the rear LCD screen. Push ✛ to move around the zoomed display.

3) Press \mathcal{Q} or ⌛ again to instantly restore your image to normal magnification.

It can take time to skip through images on a memory card—particularly if you've been busy and haven't emptied the memory card (or cards) for a while! Fortunately, the EOS 7D Mark II can display 4, 9, 36, or 100 images on screen at any one time, which should make it easier to find a specific photograph.

Viewing image index
1) In single image playback mode press \mathcal{Q} and then turn ⌛ counterclockwise until the four image Index is displayed. Keep turning ⌛ to view 9, 36, or 100 images as required (you can turn ⌛ clockwise to reverse the sequence).

2) The current image will be highlighted with an orange frame. Use ✳ or turn ⬭ to highlight other images. Press \mathcal{Q} and turn ⌛ to move to the next screen of images.

3) When the image you want to view is highlighted, press (SET) to revert to single-image display.

› Rating images

The RATE button allows you to set a rating—from 1 (★) to 5 (★)—for images during playback. The rating you give an image can then be used to filter images for viewing using Image Jump (see page 131), or when the images are on your computer and viewed in DPP or similar.

Applying ratings is a good way of sorting images. The most obvious use is to select the images you prefer and those that are less successful. However, you can use ratings more subtly than that. One use might be to divide your images into categories on your memory card. So a rating of 1 ★ could be close-ups, 2 ★ could be portraits, and so on.

To add a rating to a still image or movie, view it in playback mode. Press RATE once to add 1 ★, a second time to add 2 ★, a third time for 3 ★, and so on. Press RATE six times to cancel the rating, returning it to 0.

> *Note:*
> RATE can be reassigned to set protection on images instead. See chapter 3 for more details.

› Comparing images

The EOS 7D Mark II can display two images on screen at a time (although the size of the images is necessarily reduced when compared to standard playback). This is a useful function for comparing two similar images—to compare the focus accuracy or composition, for example.

To compare images, press ✐/☐ while in playback mode. The image surrounded by an orange frame is the active image—press (SET) to switch between the two shots.

To change the active image, turn ◌ to skip through the photographs on the currently selected memory card. The active photograph can be magnified by pressing Q and then turning ⌂. Press (SET) to swap to the other image and then press Q to set the magnification to match the original picture. Press ✐/☐ to return to single-image view, or press ▶ to temporarily view the active image full screen.

» ERASING IMAGES

After an image has been shot it can be erased immediately during the initial review by pressing 🗑 and selecting **Erase**. The same method of erasure can be used when reviewing pictures shot previously, unless the image is protected (see page 58).

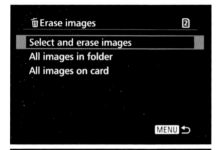

Selecting a range of images for deletion
1) Press MENU and navigate to ▶ 1. Select **Erase images**.

2) Choose **Select and erase images**, then turn ⚙ to skip through the images on the memory card.

3) When the image you want to erase is displayed, press 🔘 to toggle the erase marker. A ✓ will be displayed at the top left corner of the rear LCD screen to show that the image has been marked for erasure. The number of images that have been marked for erasure is shown at the right of the ✓ icon.

4) Repeat steps 3–4 to mark more images for erasure if necessary.

5) When you're done, press 🗑 to erase all of the marked images. Select **OK** to erase the selected images, or select **Cancel** to return to step 3.

Other deletion options
1) Press MENU and navigate to ▶ 1. Select **Erase images**.

2) Select **All images in folder**. Press ▲ / ▼ (or turn ⚙) and highlight the folder you want to erase images from. Press 🔘. Select **OK** to continue, or select **Cancel** to return to the select folder screen.

3) To erase all of the images on a memory card—except those that are protected—select **All images on card** at step 1. Select **OK** to continue, or **Cancel** to return to the main **Erase images** menu.

2 » PROTECTING IMAGES

Accidentally deleting an image from your camera's memory card is an easy (and stressful) mistake to make. Fortunately, you can protect images to prevent this from happening. Once an image has been protected, the only way to erase it is either to remove protection or to format the memory card (clearing the card and removing both protected and unprotected images alike).

Selecting a range of images for protection

1) Press MENU and navigate to the ▶ 1 menu. Select **Protect images** followed by **Select images**.

2) Turn ◌ to skip through the images on the memory card. When the image you want to protect is displayed, press ⊛ to turn the protection marker **O━** on (and again to turn the protection marker off once more). This marker will be displayed at the top of the rear LCD screen to show that the image has been protected.

3) Repeat step 2 to protect other images as required.

4) When you're done, press MENU to return to the main Protect images menu.

Other protection options

1) Select **Protect images** on the ▶ 1 menu.

2) Select **All images in folder**. Press ▲ / ▼ (or turn ◌) and highlight the folder you want to protect. Press ⊛. Choose **OK** to continue, or **Cancel** to return to the **Select Folder** screen.

3) To protect all the images on the currently selected memory card select **All images on card**. Select **OK** to continue, or **Cancel** to return to the main Protect images menu.

4) To remove protection follow steps 2–3, this time selecting either **Unprotect all images in folder** or **Unprotect all images on card**.

» MODE DIAL

The mode dial allows you to choose between the EOS 7D Mark II's six shooting modes and its three custom shooting options. The shooting modes can be roughly divided into three types: two automatic exposure modes (\boxed{A}^+ and **P**); two semi-automatic exposure modes (**Tv** and **Av**); and two manual exposure modes (**M** and **B**). The latter modes give you the greatest control over the final exposure.

To select the desired mode, press the Mode dial lock button and turn the mode dial until the appropriate icon is aligned with the mode dial index mark.

Scene Intelligent Auto	\boxed{A}^+
Program	P
Shutter priority	Tv
Aperture priority	Av
Manual	M
Bulb	B
Custom Shooting 1	C1
Custom Shooting 2	C2
Custom Shooting 3	C3

Note:
Tv stands for Time Value (another way of describing shutter speed), while Av stands for Aperture Value.

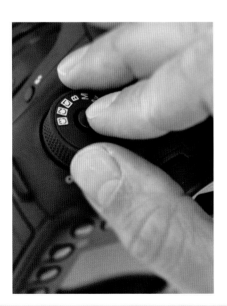

MODE DIAL **«**
The EOS 7D Mark II's mode dial has a lock at its center to prevent the mode being changed by accident.

The mode you choose is largely dependant on the level of control you want over the creation of your images. This seemingly simple shot required the use of **M** mode so I could fine tune the exposure (as well as aspects such as where the camera focused). Shooting using **A⁺** would have been too restrictive and therefore frustrating.

Settings
> Focal length: 35mm
> Aperture: f/11
> Shutter speed: 10 sec.
> ISO: 200

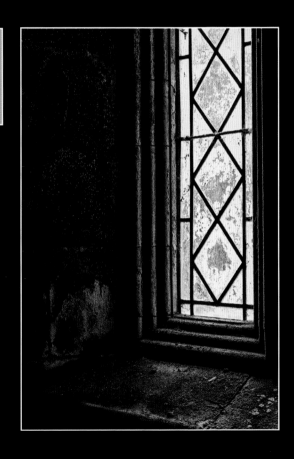

» SCENE INTELLIGENT AUTO A⁺

the range of scenes the EOS 7D Mark II can detect. The shooting functions that can either be set by you directly or are set automatically by the camera can be seen in the list on page 63. If you feel that the functions set automatically aren't that important to your style of shooting, A⁺ may well be the mode for you.

A⁺ is by far the least complex, most automated shooting mode available on the EOS 7D Mark II. Essentially it allows you to pick up the camera and begin shooting with a good chance of getting a usable image, as the camera analyzes the scene and automatically adjusts its settings based on this analysis.

This is advantageous in fast-moving situations when there may be little time to adjust the camera settings manually. However, this automation is achieved at the cost of losing control of a significant number of shooting functions. If you're a photographer who relishes controlling all aspects of the shooting experience this may be too high a price.

If you use A⁺ in Live View mode, the EOS 7D Mark II will analyze the scene and display an icon on the rear LCD screen that indicates the type of scene it thinks you are photographing. See the grid on the following page for a description of

Tips

In A⁺, ISO is set automatically. The camera will try and bias ISO so that the required shutter speed is fast enough to avoid camera shake. However, there are limits and if the light levels are too low you will still need to use a tripod. To reduce the risk of camera shake without using a tripod, switch on the Image Stabilizer if your lens has this facility.

Although a lot of the shooting functions are automated, there's no need to rush your photography. Using A⁺ is a good opportunity to think more carefully about the non-technical aspects of photography, such as composition.

Live View \boxed{A}^+ icons

	People		Non-people or landscape subjects		
	Normal	Moving	Normal	Moving	Close-up
Bright					
Bright &backlit					
Image includes blue sky					
Blue sky & backlit					
Sunsets	N/A				N/A
Spotlights					
Dark					
Dark with tripod		N/A			N/A

Using Scene Intelligent Auto [A⁺] mode

1) Turn the mode dial to [A⁺].

2) Press [Q] to change the drive mode if required.

3) If using the viewfinder, press down halfway on the shutter-release button to focus. Once focus has been achieved the active focus point(s) will flash red, the camera will beep, and the focus confirmation light ● will be displayed.

4) When using Live View, the focus point can be moved using ☼. Press down halfway on the shutter-release button to focus. Focus lock is confirmed if the focus box turns green and the camera beeps.

5) When focus has been achieved, press down fully on the shutter-release button to take the shot.

6) The captured photograph will be displayed on the rear LCD screen by default for 2 seconds unless you have altered the review time.

SETTINGS AVAILABLE IN SCENE INTELLIGENT AUTO

Focus settings
Automatically set: AI Focus AF; AF Point
User selectable: Manual focus; ☟ +
Tracking; FlexiZone–Multi; FlexiZone–
Single; Continuous AF; DOF preview

Quality settings
JPEG: ◢L; ◢L; ◢M; ◢M; ◢S1; ◢S1;
S2; S3
Raw: RAW; M RAW; S RAW

Exposure settings
Metering: Evaluative
ISO: ISO Auto; High ISO speed noise
reduction (set automatically)
Interval timer

Tone settings
Automatically set: White balance;
Auto Lighting Optimizer; Color space;
Picture Style; sRGB
User-selectable: Lens aberration
correction

Drive mode
Single shooting; High-speed
continuous; Low-speed continuous;
Silent single shooting; Silent
continuous shooting; Self-timer
(2 seconds; 10 seconds)

Flash
Automatic firing; Flash on; Flash off;
Red-eye reduction

2 » P Tv Av M B OPTIONS

Switch from [A]⁺ to one of the other exposure modes and you have access to more shooting options. With one or two exceptions noted below, these shooting options are common to all the EOS 7D Mark II's exposure modes.

Focus settings
General: DOF preview
One-Shot; AI Servo; AI Focus; AF point selection; AF-assist beam; Manual focus
Live View only: ☺ + Tracking; FlexiZone AF(); FlexiZone AF□; Continuous AF

Quality settings
JPEG: ▲L; ▲L; ▲M; ▲M; ▲S1; ▲S1; S2; S3
Raw: RAW; M RAW; S RAW

Exposure settings
General: Program shift (P only); Exposure compensation (not M or B; AEB (not B); AE lock; Multiple exposure; HDR mode
ISO: ISO Auto; Manual selection (100–H2 [51,200 equivalent]); Auto ISO range; Min. shutter spd. (Auto; Manual); High ISO speed noise reduction; Long exposure noise reduction
Metering: Evaluative; Partial; Spot; Center-weighted average

Tone settings
White balance (AWB; Preset; Custom; Correction/Bracketing); Auto Lighting Optimizer; Lens aberration correction; Highlight tone priority; Color space (sRGB; Adobe RGB)

Drive mode
General, Single; High-speed continuous; Low-speed continuous; Silent single shooting; Silent continuous shooting; Self-timer (2 seconds; 10 seconds); Interval timer; Bulb timer (B only); Anti-flicker shooting; Mirror lockup
Live View: Silent LV shooting (Mode 1; Mode 2; Disable)

Flash settings
General: Flash firing (Disable; Enable); E-TTL II metering (Evaluative; Average); Flash sync. speed in Av mode (Auto; 1/250–160sec. Auto; 1/250 sec.); Red-eye reduction (Disable; Enable)
Built-in flash settings: Flash mode (E-TTL II; Manual flash; MULTI flash); Shutter sync. (1st curtain; 2nd curtain); ➤ exp. comp.; Wireless func. (Enable; Disable)
External flash: Speedlite dependant

» PROGRAM (P)

P is superficially similar to ⒶＴ, in that the EOS 7D Mark II automatically selects the shutter speed and aperture required for the correct exposure. However, unlike ⒶＴ you aren't locked out of making adjustments to the exposure if desired. This can be achieved by using exposure compensation, selecting a different ISO setting, or using Program Shift. You are also free to choose from a full range of options, such as Picture Style—think of **P** as the midpoint between ⒶＴ and modes such as **Tv** and **M**.

Program Shift allows you to alter the automatically selected shutter speed and aperture pairing, allowing you to maintain the same level of exposure overall.

To set Program Shift, turn ✺ once you've pressed halfway down on the shutter-release button to activate the exposure meter. Program Shift will be cancelled once you've pressed the shutter-release button down fully to take your shot.

Using Program **P** mode

1) Turn the mode dial to **P**.

2) If using the viewfinder, press the shutter-release button down halfway to focus. Once focus has been achieved the active focus point(s) will flash red, the camera will beep, and the focus confirmation light ● will be displayed.

3) If using Live View, select the focusing method by pressing ⓠ. When FlexiZone **AF☐** is selected the focus point can be moved around the rear LCD screen using ✺. Press the shutter-release button down halfway to focus—focus lock will be confirmed by the focus box turning green and the camera beeping.

4) Turn ✺ to alter the shutter speed and aperture combination or turn ◯ to apply exposure compensation if required.

5) Press the shutter-release button down halfway again. When focus has been achieved, press down fully on the shutter-release button to take the shot.

6) The captured photograph will be displayed on the LCD by default for 2 seconds unless the review time has been adjusted.

Tv puts you in control of the EOS 7D Mark II's shutter speed, letting the camera choose the required aperture (**Av** mode, described on pages 68–69, reverses this). You'd typically use **Tv** when shutter speed is more important than the aperture. Sports/action is a good example of the type of photography when this would be the case.

If there's absolutely no movement in a scene then the shutter speed you select is relatively unimportant. However, once there is movement the shutter speed you choose becomes critical to how that movement is recorded in the final image.

Fast movement requires a fast shutter speed if you want to "freeze" the motion. However, there are other factors that need to be considered too. The distance between you and your moving subject is important, for example, and the closer the subject is to the camera, the faster the shutter speed will need to be. A subject moving across the image frame will also need a faster shutter speed than a subject moving toward or away from the camera.

Slowing the shutter speed down will make a moving subject appear more blurred and soft—with a sufficiently long shutter speed a moving subject may even disappear entirely (this can be an effective way to "remove" people from a scene, particularly when an extreme ND graduated filter is used). The slower the shutter speed, the more necessary a tripod or other support will become.

Using Shutter priority **Tv** mode

1) Turn the mode dial to **Tv** and set the required shutter speed by turning 🗘. If the maximum aperture figure (for the lens) blinks in the viewfinder or in Live View your image will be underexposed—you will need to use a longer shutter speed or increase the ISO.

If the minimum aperture figure blinks, the image will be overexposed, so you will need to use a faster shutter speed or decrease the ISO.

2) Press ▣ to change the shooting settings if required.

3) If using the viewfinder, press down halfway on the shutter-release button to focus. Once focus has been achieved,

the active focus point(s) will flash red, the camera will beep, and the focus confirmation light ● will be displayed.

4) If using Live View, select the focusing method by pressing **Q**. When FlexiZone **AF☐** is selected, the focus point can be moved around the rear LCD screen using ⁑. Press halfway down on the shutter-release button to focus—focus lock will be confirmed by the focus box turning green and the camera beeping.

5) When focus has been achieved, press down fully on the shutter-release button to take the shot.

6) The photograph will be displayed on the LCD by default for 2 seconds unless the review time has been adjusted.

MOVEMENT ⌄

The blur caused by using a slow shutter speed can help to create a sense of movement. To make this image, the camera was panned to follow the movement of the horse.

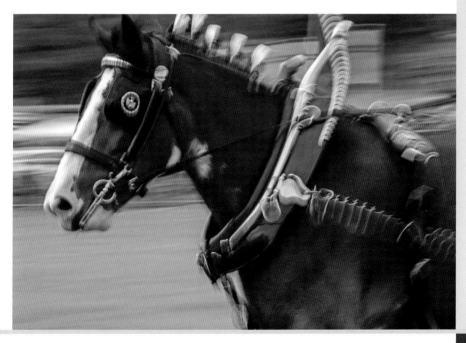

» APERTURE PRIORITY (Av)

Inside every Canon EF and EF-S lens is a variable iris known as the aperture. When you open the aperture, you allow more light to pass through the lens; closing the aperture down reduces the amount of light passing through the lens. The aperture is controlled via the camera and—in conjunction with the shutter speed—it determines how much light reaches the sensor.

Another role performed by the aperture is controlling the amount of acceptable sharpness in an image. The focus point is always the sharpest part of the image. However, by making the aperture smaller a zone of sharpness extends out from the focus point. This zone of sharpness is known as "depth of field." Depth of field always extends further back from the focus point than it does in front.

Av is the mode to use if you want control over depth of field. Typical users of **Av** would be landscape and portrait photographers who would typically be looking to maximize and minimize depth of field respectively.

One problem with judging the extent of the depth of field is that the aperture is always held open at its maximum value. Therefore, when you look through the viewfinder (or at the Live View display) you always see the scene with the shallowest depth of field the lens will allow. The aperture is only closed to the value you set when you press the shutter-release button down fully to make an exposure.

Fortunately, there's a solution: pressing and holding the EOS 7D Mark II's depth-of-field preview button closes the aperture to the value you've selected for your shot, which will show you the depth of field you will get. However, it also means that when you have selected a small aperture the viewfinder will go dark, which isn't ideal if you're working in low light. In this instance, a better solution is to switch to Live View temporarily. Live View compensates for the drop in light levels, showing both a correctly exposed image and the right degree of depth of field.

Using Aperture priority **Av** mode
1) Turn the mode dial to **Av** and set the required aperture by turning ⌂. If the shutter speed shows **30"** and this figure blinks in the viewfinder or in Live View,

your image will be underexposed—you will need to use a larger aperture or increase the ISO. If the shutter speed shows **8000** and the figure blinks, the image will be overexposed—you will need to use a smaller aperture or decrease the ISO.

2) Press Q to change the shooting settings if required.

3) If using the viewfinder, press halfway down on the shutter-release button to focus. Once focus has been achieved, the active focus point(s) will flash red, your camera will beep, and the focus confirmation light ● will be displayed (One-Shot AF).

4) If using Live View, select the focusing method by pressing Q. When FlexiZone **AF☐** is selected the focus point can be moved around the rear LCD screen using ✳. Press halfway down on the shutter-release button to focus—focus lock will be confirmed by the focus box turning green and the camera beeping.

5) When focus has been achieved, press down fully on the shutter-release button to take the shot.

6) The photograph will be displayed on the rear LCD screen.

OUT OF FOCUS ❯❯

We tend to skip over areas of an image that are out of focus. Using a large aperture is therefore an effective way to make your subject the focal point of an image.

Landscape photography usually involves maximizing depth of field through the use of small apertures. However, in this shot the combination of a long focal length lens and a wide aperture has created a simpler, more satisfying image. If the background had been sharper it would have been more distracting.

Settings
> Focal length: 200mm
> Aperture: f/4
> Shutter speed: 1/60 sec.
> ISO: 200

» MANUAL (M) AND BULB (B)

The **M** and **B** modes put you in complete control of the exposure of your images. In **M** mode you set both the shutter speed and aperture independently, and the exposure won't change if the light level alters or you fit a light-sapping filter. This means you have no one to blame but yourself if you forget to adjust the exposure accordingly.

In **B** mode you set the aperture; the length of time the shutter is open for depends on how long you hold the shutter-release button down (or, more practically, how long you lock the shutter open for with a remote release).

B mode is typically used when you require a shutter speed in excess of 30 sec., as you can manually select shutter speeds that are faster than this. Correctly exposed images using shutter speeds longer than 30 sec. are generally only possible in very low light or when extremely dense ND filters are used.

There are a few practical considerations to take into account when using long shutter speeds. The first is that it's a drain on the battery, so it's recommended that you use a freshly charged battery to avoid proceedings coming to a halt.

Another factor to consider is image noise, which will become more visible the longer the exposure. The EOS 7D Mark II has a long-exposure noise-reduction facility (see page 98), but it is worth noting that this takes the same length of time as the original exposure. Therefore, if you're using very long exposures, it is worth switching it off. This will increase noise (this can be dealt with in postproduction), but it will also reduce the risk of the battery dying, and therefore losing the image before the exposure has completed.

> **Notes:**
> **M** is best used with a definite ISO value rather than using Auto ISO.
>
> Auto ISO is locked at ISO 400 when using **B**.
>
> **Bulb Timer** on the 📷 4 menu can be used to set a specific duration for your **B** exposures, without the need for you to hold down the shutter-release button.

Using Manual **M** mode

1) Turn the mode dial to **M** and set the required shutter speed by turning . Set the aperture by turning ⭕. The correct exposure is set when the exposure level indicator mark is centered next to the exposure index mark at the right of the viewfinder. The lower the exposure level indicator mark is, the greater the chance of underexposure; the higher it is the greater the risk of overexposure.

2) Press 🇶 to change the shooting settings if required.

3) If using the viewfinder, press halfway down on the shutter-release button to focus. Once focus has been achieved, the active focus point(s) will flash red, the camera will beep, and the focus

confirmation light ● will be displayed (One-Shot AF).

4) If using Live View, select the focusing method by pressing 🇶. When FlexiZone **AF**□ is selected the focus point can be moved around the rear LCD screen using ✴. Press lightly halfway down on the shutter-release button to focus—focus lock will be confirmed by the focus box turning green and the camera beeping.

5) When focus has been achieved, press down fully on the shutter-release button to take the shot.

6) The captured photograph will be displayed on the LCD by default for 2 seconds unless you have adjusted the review time.

TIME **«**
M isn't ideal if you're rushing around taking photos. However, if you have time to stop and think, it cannot be beaten for the control it gives you over your exposures.

FILTERED »
Long exposures using **B** in normal daylight—such as this 3-minute exposure—require the use of very dense ND filters (see page 217).

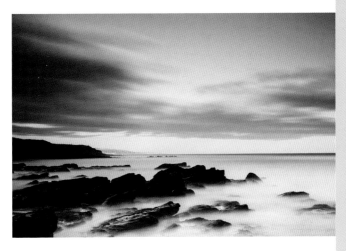

Using Bulb **B** mode

1) Turn the mode dial to **B** and set the required aperture by turning ⚞.

2) Press Ⓠ to change the shooting settings if required.

3) If using the viewfinder, press halfway down on the shutter-release button to focus. Once focus has been achieved, the active focus point(s) will flash red, the camera will beep, and the focus confirmation light ● will be displayed (One-Shot AF).

4) If using Live View, select the focusing method by pressing Ⓠ. When FlexiZone **AF□** is selected, the focus point can be moved around the rear LCD screen using

✳. Press halfway down on the shutter-release button to focus—focus lock will be confirmed by the focus box turning green and the camera beeping.

5) When focus has been achieved, press down fully on the shutter-release button to take the shot. Keep the shutter-release button pressed down until the required exposure is achieved. The accumulated length of the exposure (in seconds) is displayed on the top LCD panel during the exposure.

6) The captured photograph will be displayed on the rear LCD screen by default for 2 seconds, unless the review time has been adjusted.

2 » MAKING MOVIES

The EOS 7D Mark II has been designed with movie shooters very much in mind. The key improvement over the EOS 7D is the ability to continuously auto focus during movie recording with USM lenses released after 2009. However, the noise of the lens focusing can be an issue if you use the camera's built-in microphone, so a better option is to use one of Canon's small (but growing) range of STM lenses, which are designed for near-silent focusing when shooting movies.

Shooting a movie
1) Turn the Live View/Movie shooting switch to '🎥. Your EOS 7D Mark II will switch automatically to Live View—movies cannot be composed by looking through the viewfinder.

2) Press the shutter-release button halfway to focus. Adjust the focal length of your lens too, if necessary.

3) Press START/STOP to begin recording. A red ● mark will be displayed at the top right of the rear LCD screen to show that recording has begun.

4) Press START/STOP to stop recording.

Warning!

Do not touch the built-in microphone next to the hotshoe during recording, as this will create extraneous noise.

Notes:
When shooting movies, use large-capacity memory cards with a fast read/write time.

The longest continuous clip you can record is 29 minutes, 59 seconds. Movie recording will automatically stop after this. Individual movie clips also cannot exceed 4GB in size. A new clip will be started automatically once either limit has been reached.

See chapter 3 for menu options relating to movie shooting.

› The mode dial and movies

The amount of control you have over the exposure of your movies depends on how the mode dial is set. Shoot a movie using Ⓐ†, **P**, or **B** and the exposure is set automatically. You still have control over functions such as movie resolution and you can set exposure lock and exposure compensation in **P** and **B** modes.

Greater exposure control is possible when shooting using **Tv** and **Av**, which allow you to set the shutter speed and aperture respectively (although the ISO is adjusted automatically).

When you set the mode dial to **M** you have the most control over the exposure of your movies. Using **M** allows you to alter the ISO, aperture, and shutter speed (although these are best set before recording if possible). However, the lowest shutter speed available is 1/30 sec.

EXPOSURE ⨾
Exposure alters automatically in fluctuating lighting conditions in all modes other than **M**.

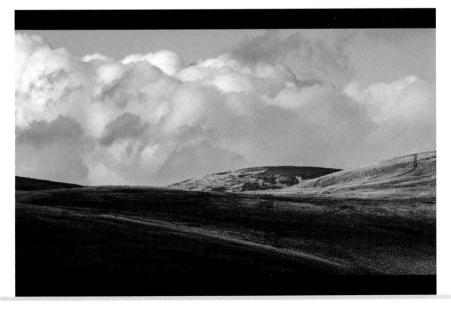

› Quick Control

The movie Quick Control screen is controlled the same way as the Quick Control screen in Live View when shooting still images. Press **Q** to alter any or all of the following before movie recording: **AF method**, **Drive mode** (still images only), **Movie recording size**, **Audio recording level**, **Headphone volume**, **Still image quality**, **White balance**, **Picture Style**, and **Auto Lighting Optimizer** (disabled in **M** and **B** modes).

› Movie color

Movie footage is similar to shooting JPEGs, in that whatever image settings are applied during shooting will be hard to undo later. If you plan to use your movie footage straight from the camera this isn't a problem, but if you plan to alter the look of your footage in postproduction it's better to start with footage that has relatively flat color, low contrast, and the correct white balance.

You will find that it is far easier to add contrast and saturation in postproduction than it is to remove them, so check that the selected Picture Style and white balance settings are right for your needs before you shoot.

› Live View

Movies are only shot using Live View, so you can't use the viewfinder to compose your shots. Pressing **INFO.** toggles between screens with different levels of shooting information. The picture displayed before and during recording reflects the following functions that you or the camera have set automatically: Auto Lighting Optimizer, Picture Style, White balance, Peripheral illumination and chromatic aberration correction, Highlight tone priority, exposure, and depth of field.

» MOVIE SHOOTING TIPS

› Exposure

Visually, the aperture you use has exactly the same effect when shooting a movie as it does when shooting a still image—a large aperture restricts depth of field; a smaller aperture increases depth of field. Using a large aperture to restrict depth of field will give your movie footage a very cinematic esthetic, particularly when a long focal length lens is used. However, care should be taken with moving subjects, as these can easily drift in and out of focus.

The shutter speed you choose has a less obvious impact on the look of your movies. Movies are shot at a certain frame rate, but the selected shutter speed doesn't necessarily have to match the frame rate. In **M** mode you can choose any shutter speed between 1/30 sec. and 1/4000 sec. (although the ISO may need to be increased considerably to achieve faster shutter speeds). However, using fast shutter speeds will produce very staccato movie footage that will appear crisp, but is surprisingly difficult to watch for more than a few seconds.

Although it sounds counterintuitive, a slight amount of blurring between frames actually produces footage that is more comfortable to watch. The general rule when selecting a shutter speed is to use one that's twice the chosen frame rate. A shutter speed of 1/50 sec. is the ideal when shooting at 25 fps, for example, or 1/60 sec. when shooting at 30 fps. Shooting at the lowest possible shutter speed (1/30 sec.) can result in smeary footage, especially if there's a lot of movement in the scene being filmed.

> ### Tip
>
> *Use an ND filter to reduce the shutter speed in bright conditions.*

MOVEMENT ❯❯
A slight blur to movement in movie footage makes it easier on the eye.

The EOS 7D Mark II has a very simple built-in playback and editing suite for your movies. Playing back your movie after shooting is a good habit to get into, as it will ultimately save time if you check that everything is as it should be at the time of shooting, rather than mount a reshoot (if this is even possible) at a later date.

Unfortunately, you can't magnify a movie on the camera's rear LCD screen, which means checking critical focus isn't easy—if you're serious about shooting movies it's worth buying an LCD field monitor. These are LCD panels, typically 7–8 inches in size, that connect via the HDMI output and give you a larger, more detailed view of what's being shot.

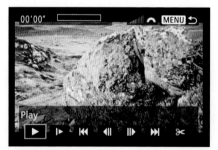

Playing back a movie

1) Press ▶. Navigate to the movie you wish to view; movie files differ from still images as **SET** 🎞 is displayed at the top left corner of the rear LCD screen.

2) Press **SET** to display the movie playback panel. The play symbol, ▶, is highlighted by default when you first view the playback panel. Press **SET** to play the movie. Turn 〰 to increase or decrease the volume.

3) When the movie finishes you will be returned to the first frame of the movie.

Movie playback panel options		
▶	Movie playback.	
I▶	Slow motion. Press ◀ / ▶ to decrease/increase speed.	
◀◀	Jump back to the first frame of the movie.	
◀I		Move back one frame every time **SET** is pressed. Hold down **SET** to skip backward.
	I▶	Move forward one frame every time **SET** is pressed. Hold down **SET** to skip forward.
▶▶		Jump forward to the last frame of the movie.
✂	Movie editing tools.	

› In-camera editing

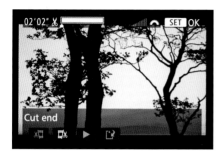

The EOS 7D Mark II's built-in editing suite allows you to trim either end of your movies. Editing movies in-camera isn't ideal, though, and far greater control (such as slicing up footage and rearranging the order of those slices) requires the use of movie-editing software on your computer.

Editing software was once expensive and hard to find, but now there is a wide range of relatively inexpensive tools that are readily available and easy to use. Good examples include Adobe Premiere Elements and Apple's iMovie.

Editing movies

1) Follow step 1 in *Playing back a movie* on page 78, then select ✂ from the playback control panel.

2) To cut the beginning of the movie, select ⛏; choose ⛏ to trim the end of your movie. Turn ◌ to set the trimming point backward and forward a frame

respectively, or hold down ◄ / ► to skip backward and forward more quickly. The light gray time bar at the top of the rear LCD screen shows you how much of the movie will be left once it has been edited. Press ⑄ when you've set the edit point.

3) Highlight ► and press ⑄ to view the edited movie.

4) If you're happy with the edited movie, highlight ⊡ to save the movie to the memory card. Highlight **New File** if you want to create a new movie file with the edit applied, **Overwrite** if you want to save over the original movie, or **Cancel** to return to the editing screen. Press ⑄ and follow the on-screen instructions.

5) At any point in the editing process, pressing MENU will take you back to the movie playback control panel. Highlight **OK** and press ⑄ to exit without saving your changes, or **Cancel** to return to the editing screen.

> **Note:**
> Movies are edited in 1-second increments, so the edit may not be as precise as anticipated.

3 MENUS

Although the EOS 7D Mark II is bristling with buttons, you will need to use the menu system if you really want to take control of it. At first glance this appears daunting, but once you understand its logic it's easy to find the required functions quickly.

The camera's menus are divided into six color-coded sections, each of which is represented by a symbol at the top of the rear LCD: Shooting ◘ (which includes options for Live View shooting, and when the ▶/◘ switch is set to ▶, movie specific options), Auto Focus **AF**, Playback ▶, Set-up ♀, Custom Functions ⚙, and My Menu ★.

Each section is sub-divided into separate menu screens. The number of small squares at the left of the LCD (below the section icon) indicates which particular subsection you're currently viewing.

The total number of menu screens available is dependant on the mode you are using—fewer menu screens are shown when the mode dial is set to [A⁺], for example. It's only when you select one of the other shooting modes that you have access to the full range of options.

CONFIGURATION ⌃
Canon has used the same basic menu style for its EOS cameras for a number of years, so if you've used a Canon camera before there will be much that's familiar.

READY »
Any subject that requires split-second timing needs you to set up your camera correctly before you raise it to your eye. Familiarity with the menu system means you can prepare your camera quickly and efficiently.

Changing menu options

1) Press MENU.

2) Press ◄ / ► or turn 🔆 to jump left or right between the different menu sections and their various subsections. As you jump between the various menu sections the relevant icon on a tab at the top of the LCD will be highlighted. The subsection screen number is shown as a highlighted square in a row of squares below the section icon strip.

3) When you reach the required menu screen press ▲ / ▼ to move the highlight bar up or down the various functions on the menu screen. Press 🔘 when the function you want to alter is highlighted.

4) Highlight the required option for your chosen function by pressing either ▲ / ▼ for simple menu options or 🔆 when there is a series of options arrayed around the screen. Press 🔘 to make your choice. If you press MENU before making your choice you will jump back to the previous menu screen without altering the option.

5) To return directly to shooting mode press MENU, or lightly down on the shutter-release button when viewing a main menu screen.

> **Note:**
> Some options need you to confirm your choice before proceeding. This is done either by selecting **OK** to continue or **CANCEL** to reject the choice. Highlight the required option and press 🔘.

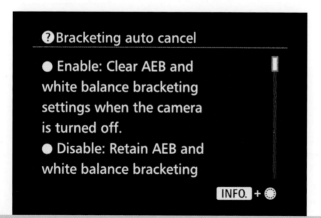

INFORMATION **«**
Whenever INFO. is displayed at the bottom of a function screen you can press the **INFO.** button to call up a short description of that function.

» SHOOTING 1 📷

› Image quality

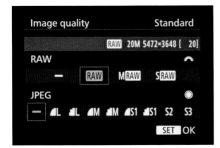

As with all of Canon's EOS cameras, the EOS 7D Mark II gives you the choice of saving the images you shoot either as JPEG, Raw, or Raw+JPEG files.

If you choose JPEG, the EOS 7D Mark II processes your images as you shoot, using the image controls—such as Picture Style and white balance—selected before shooting. These image adjustments are "baked" into the JPEG, making them harder to unpick later without reducing image quality unacceptably.

JPEG images take up less room on a memory card than an equivalent Raw file. This is because JPEGs are compressed using a system that simplifies fine detail within the image. Although this sounds undesirable, in practice it's often hard to spot where the loss has occurred unless you look closely at an image at 100%—or even 200%—magnification. The EOS 7D

Mark II allows you to choose between two levels of compression: ◢ **Fine** and ◢ **Normal**. ◢ does not apply as much compression as ◢, so image quality is not compromised as much, but the images take up more room on the memory card as a result.

If memory card space is an issue, you can also select one of five options to adjust the pixel resolution of your images: **L** (5472 x 3648), **M** (3648 x 2432), **S1** (2736 x 1824), **S2** (1920 x 1280), and **S3** (720 x 480).

The drawback to using a lower-resolution option is that the scope for making large, high-quality prints will be reduced. However, when shooting images purely for web sites or electronic documents **S2** or **S3** will be ideal.

If you value image quality over convenience, then Raw is the image format to choose. A Raw file is a "package" of all the information gathered by the sensor at the time of shooting. You can only view Raw files in Raw conversion software, so if you need an image for another purpose you will need to convert the Raw file into a more useful form such as JPEG or TIFF. This means setting time aside for postproduction duties.

However, unlike shooting JPEG you have far more control over the final look of

the image. With Raw you're free to adjust image parameters such as Picture Style or white balance without any loss of quality. This means you can revisit your Raw files and adjust them in an infinite number of ways as often as you like.

Notes:
Your EOS 7D Mark II is supplied with Canon's DPP software, which is a very comprehensive and useful Raw conversion tool. However, other options include processing the Raw file in-camera or using third-party products such as Adobe Photoshop or Lightroom, or Phase One's Capture One Pro.

Raw data is never overwritten on your computer. Instead, the "recipe" of changes you make are stored in a separate .XMP file in the same folder as the Raw file, or in a database when using software such as Lightroom. The changes are only applied when you export the image in a different format (usually JPEG or TIFF).

If you have a sufficiently large memory card (or two memory cards), shooting Raw+JPEG will give you the best of both worlds—a JPEG for immediate use and a Raw file that can be processed later.

› Image review time

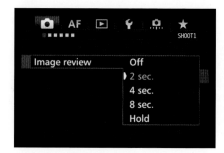

Determines how long an image is displayed automatically on the rear LCD screen after it has been taken.

Options:
2 sec. (default); **4 sec.**; **8 sec.**; **Off** (no image is displayed); **Hold** (the image remains on screen until you press any of the controls, or until the camera powers down automatically).

› Beep

Sets the EOS 7D Mark II to make an audible beep to confirm focus lock and during self-timer countdown.

Options:
Enable; **Disable** (the camera is silent, other than mechanical noise caused by the mirror or shutter).

› Release shutter without card

Allows you to fire the shutter when there is no memory card installed in your EOS 7D

Mark II. Although an image is displayed on the rear LCD screen, it will not be saved.

Options:
Enable (required when you use "tethered shooting"—see chapter 8); **Disable** (a warning will be displayed on the LCD if there is no memory card and the shutter will not fire).

› Lens aberration correction

Not all lenses are equal, and high-resolution sensors (such as the one found in the EOS 7D Mark II) will quickly reveal any flaws. Fortunately, particular lens designs are flawed in a quantifiable way: **Lens aberration correction** allows some of these flaws to be corrected automatically at the time of shooting

Options:
Peripheral illumin.: Used to correct vignetting, which is a visible darkening at the corners of an image, more likely to be

seen when using a wide-angle lens than a telephoto focal length. As **Peripheral illumin.** can potentially emphasize noise at the corners of your images, the amount of correction applied is reduced the higher the ISO value you use.

Chromatic aberration: Chromatic aberration is caused when the optics in a lens aren't able to focus the various wavelengths of colored light to exactly the same point. This is seen as colored fringing along the boundaries of light and dark areas of an image. There are two types of chromatic aberration: axial and transverse.

Axial chromatic aberration is visible across the entirety of an image when a lens is used at maximum aperture—the more the lens aperture is stopped down (made smaller) the more the effects of axial chromatic aberration are reduced. As a result, axial chromatic aberration usually disappears entirely when the aperture is set a few stops smaller than maximum.

Transverse chromatic aberration is seen only at the edges of an image and is not reduced by stopping the aperture down. When it is set to **Enable**, **Chromatic aberration** corrects for the effects of transverse aberration.

Distortion: Corrects the way that lenses appear to warp straight lines in an image. There are two types of distortion: pincushion and barrel. Pincushion

distortion results in straight lines appearing to bow inward toward the center of the image; barrel distortion results in straight lines bowing outward. Zoom lenses often display both types of distortion—one at either end of the zoom range—with the mid focal length typically distortion-free.

> *Notes:*
> Lens aberration correction only applies when shooting JPEGs— if you are shooting Raw it would be applied in postproduction.
>
> Lens aberration correction requires the profile for a particular lens to be installed on your EOS 7D Mark II. By default there are profiles for 28 Canon lenses ready for use—you can add or delete a lens using the supplied EOS Utility software, but only Canon lenses are supported.

› Flash control

See chapter 5 for more detail.

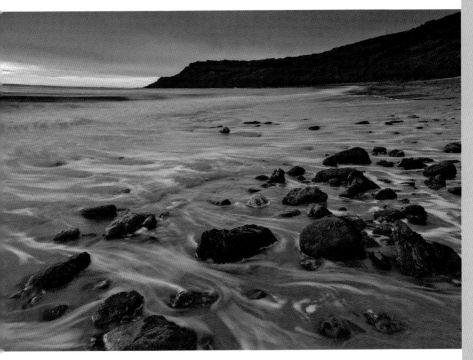

Tip

Vignetting is not necessarily a bad thing. Some darkening of the corners of an image will help focus attention at the center of the photograph, which is ideal if this is where your subject is placed.

DISTORTION ⌃

Pincushion distortion makes straight horizon lines appear to curve upward from the center of the image.

› Expo. comp./AEB

Allows you to override the suggested exposure of an image, as well as shoot a bracketed sequence of images. See page 47 for details.

› ISO speed settings

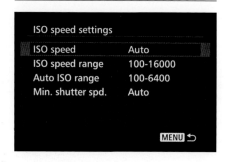

Allows you to customize the EOS 7D Mark II's ISO control.

Options:
ISO speed (allows you to choose an ISO setting); **ISO speed range** (allows you to set the minimum and maximum ISO setting that can be selected manually); **Auto ISO range** (allows you to set the minimum and maximum ISO setting that can be selected when Auto ISO is used); **Min. shutter speed** (allows you to set the slowest shutter speed that you want to maintain for as long as possible when using

Auto ISO. The ISO will be adjusted to maintain this shutter speed until the ISO cannot be increased any further).

Notes:
When you view the ISO speed screen after setting the ISO speed range, the ISO value below the selected minimum or above the selected maximum value will be ghosted out and cannot be selected. **Auto** is always available.

Min. shutter speed allows you to specify the slowest shutter speed you want the camera to use, or you can allow the camera to decide the shutter speed by setting **Auto**. In this instance, the camera will base its shutter speed selection on the focal length of the lens.

› Auto Lighting Optimizer

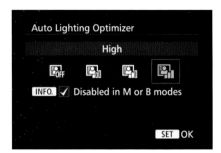

This option automatically processes images so that they have a more pleasing spread of tones, typically by lightening the shadows and reining in the highlights. However, when using higher ISO settings the shadow areas in your image may appear unacceptably noisy and scenes that are low in contrast may appear flatter still.

Options:
🔲 Low; 🔲 Standard; 🔲 Strong; 🔲 Disable.

> **Note:**
> The effect of Auto Lighting Optimizer can be replicated easily during the Raw conversion process, so it is more suited to shooting JPEG and movies.

› White balance

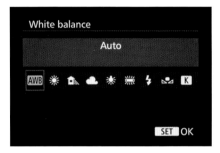

Most light sources have a color bias to one degree or another. This is usually either a red bias (resulting in the light being "warm") or a blue bias ("cool" light). If there's only a subtle bias, our eyes usually adjust so that we don't realize that light is not neutral in color. It's only when the color bias is extreme (such as the warmth of candlelight), or when two different light sources are seen together that we really notice a bias. This variation in the color of light is known as a variation in "color temperature," which is measured using the Kelvin scale (K).

A camera will faithfully record the color bias of light if you don't intervene, which can produce images that may appear too warm or too cool. White balance is the tool used to compensate for the color bias of light so that whites in an image are perfectly white.

3

Your EOS 7D Mark II lets you set the white balance for a particular light source either by using one of the presets built into the camera or by specifying a Kelvin value. For the greatest accuracy you can also create a custom white balance for a particular light source.

White balance settings

AWB	White balance is set automatically
☀	Daylight/5200K—sunny conditions
⌂	Shade/7000K—shadow conditions
☁	Cloudy/6000K—overcast conditions
💡	Tungsten/3200K—domestic lighting
🔆	White fluorescent lighting/4000K
⚡	Flash/5500K
⊾	Custom white balance
K	Specific Kelvin value

› Custom white balance

Auto white balance (AWB) is by no means foolproof, and there are times when it won't work as intended. For example, when there is one predominant color in a scene AWB will often try to compensate for this color, resulting in inaccurate colors. In this instance, a better option is to create a custom white balance setting instead.

To create a custom white balance you must first take a photo of a neutral white surface, which should be lit by the same light as the scene you're shooting, and ideally fill the viewfinder for greatest accuracy. Switch your lens to MF (it doesn't matter whether the white surface is in focus or not) and adjust the exposure so that the surface is almost (but not quite) clipping the right edge of the histogram (this generally means applying 1–2-stops of positive exposure compensation).

› WB Shift/BKT

Setting a custom white balance

1) Select **Custom White Balance**.

2) The white reference image you've just shot should be displayed (turn 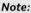 if it isn't, or if you want to use a different image to create the custom WB). Press (SET).

3) Select **OK** to create the custom WB or **Cancel** to return to step 2.

4) Once you've created your custom white balance select the custom WB preset.

> **Note:**
> A custom white balance is typically specific to one particular scene. If you move to a different scene with different lighting you will need to create a new custom WB.

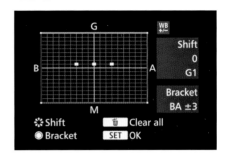

Another method of refining the white balance is to temporarily adjust a standard WB preset using **WB Shift/BKT**. This option allows you to modify a particular preset by adding more green (G), magenta (M), blue (B), or amber (A) to the color correction. You can also bracket the white balance so that three shots are taken using different WB settings. However, this is all most relevant if you shoot JPEGs—when shooting Raw, the white balance can be refined in postproduction without any loss of image quality.

Setting WB Shift

1) Select **WB Shift/BKT**.

2) Use ✳ to move the square WB adjustment point around the grid. Moving the point to the right will increase the amber bias (making the image warmer), while moving it to the left adds more blue (making it cooler). Moving the point up

and down adds more green and magenta respectively. These latter two adjustments are most useful when shooting under fluorescent lighting, which often has a green/magenta color bias.

3) To set WB bracketing turn ⬡. Turning ⬡ to the left sets the G/M bracketing; turning it to the right sets the B/A bracketing. If you choose to bracket WB, the next three shots that you take will use the WB of the preset, then the preset with a blue bias, and then the preset with an amber bias (or the preset, then magenta, then green if you bracket G/M). The cycle repeats until WB bracketing is cancelled.

4) Press ⓢⓔⓣ to set the WB adjustment and return to the main ⬛ 2 menu screen or press 🗑 to clear the WB adjustments and return to step 2.

Notes:
If you switch to Live View, the modifications you make to a WB preset will be immediately apparent on screen.

When WB shift has been applied, ᵂᴮ will be shown on the detailed shooting information screen and ❶ will be displayed in the viewfinder. During WB bracketing the preset icon will flash on the detailed shooting information screen.

The number of bracketed shots can be altered on the ⬛1 screen.

› Color space

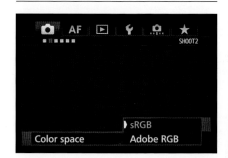

A color space is a mathematical model that allows colors to be represented using a string of numbers. RGB (used by your EOS 7D Mark II and computer monitor) defines colors by mixing red, green, and blue in different proportions—combining green

and blue at maximum saturation would create cyan, for example.

Your EOS 7D Mark II allows you to record your images using either the **sRGB** color space or the **Adobe RGB** color space. As **Adobe RGB** encompasses a larger and richer range of colors than **sRGB**, you would think that more is better and that **Adobe RGB** is the option to choose. Generally that's correct.

However, some devices, such as monitors and printers, use even smaller color spaces. Internet browsers also prefer images to be **sRGB**. Therefore, if you plan to print or use your images online without adjustment, **sRGB** is the better option.

The choice is particularly important if you use JPEG—Raw files can be tagged with a different color space when they are imported for postproduction.

> **Note:**
> sRGB is used automatically when the mode dial is set to Ⓐ⁺.

» SHOOTING 3 📷

› Picture Style

A Picture Style allows you to alter the way that color, contrast, and sharpness are recorded in your images. This is achieved by selecting one of a number of Picture Style presets or by defining your own personal Picture Style (either in-camera or by using Canon's Picture Style Editor and applying the new style to your Raw files or uploading it to your camera using EOS Utility).

When you use Ⓐ⁺, the Auto Picture Style is applied and cannot be altered. In all other shooting modes you have full control over which Picture Style is applied to your images.

Presets	Description
🎨A Auto	The Picture Style is automatically modified depending on the shooting situation.
🎨S Standard	Suitable for general photography.
🎨P Portrait	Sharpness is set lower than Standard.
🎨L Landscape	Greens and blues are more saturated.
🎨N Neutral	Natural colors with lower saturation.
🎨F Faithful	Lower saturation than Neutral.
🎨M Monochrome	Converts images to black and white.
🎨1 User Defined 1–3	–

Setting a Picture Style

1) Select **Picture Style** on the 📷 3 menu.

2) Highlight the required Picture Style; press ⑤ to choose it and return to the 📷 3 menu.

Notes:
A Picture Style can also be set via the Quick Control screen.

The effects of a Picture Style can be undone in postproduction when shooting Raw. However, you will still see the effects of the selected Picture Style in Live View or in playback. This is particularly useful when using the Monochrome Picture Style.

You can download additional Picture Styles from Canon's Japanese website at www.canon.co.jp/imaging/picturestyle/file/index.html.

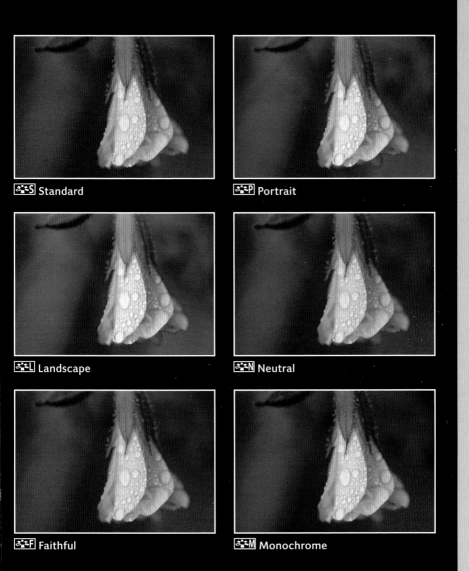

⊡S Standard

⊡P Portrait

⊡L Landscape

⊡N Neutral

⊡F Faithful

⊡M Monochrome

Detail settings

You don't need to stick with the default Picture Style settings—each can be modified through the adjustment of one or all of four detail settings: ⬗ **Sharpness**, ⬗ **Contrast**, ⬚ **Saturation**, and ⬗ **Color tone** (Monochrome is an exception, as you shall see).

To adjust these settings, highlight the Picture Style you wish to alter, press **INFO.**, and then select the desired detail setting. Press ◄ to decrease the effect of the setting or ► to increase it, and then (SET) to confirm your adjustment.

To clear your settings, highlight **Default set.** at the bottom of the screen and press (SET) or press MENU to return to the main Picture Style menu.

Presets	Description
⬗ Sharpness	0 (no sharpening applied) to 7 (maximum sharpening)
⬗ Contrast	- Low contrast / + High contrast
⬚ Saturation	- Low color saturation / + High color saturation
⬗ Color tone	- Skin tones more red / + Skin tones more yellow

When you modify the ⬚M **Monochrome** Picture Style, the ⬚ **Saturation** and ⬗ **Color** parameters are replaced by ⬗ **Filter effect** and ⊘ **Toning effect**. Filter effect mimics the use of colored filters when shooting with black-and-white film (see grid above right), while **Toning effect** adds a subtle color wash to your images. Choose between **N: None, S: Sepia, B: Blue, P: Purple**, or **G: Green**.

Presets	Description
N: None	No filter effect applied
Ye: Yellow	Blues are darkened; greens and yellows are lightened
Or: Orange	Blues darkened further; yellows and reds lightened
R: Red	Blues very dark; reds and oranges lightened
G: Green	Purples darkened; greens lightened

User Defined Picture Style

Detail set.　　　User Def. 2
Picture Style　　Standard
Sharpness　　　0+--+--+7
Contrast　　　　=+--+0--+--=
Saturation　　　=+--+0--+--=
Color tone　　　=+--+0--+--=

MENU ↩

Changing the preset Picture Styles is all very well, but you will have to carefully unpick your changes if you want to revert to the default settings. A better solution is to modify a preset and save the result as **User Def. 1**, **2**, or **3**.

Highlight **User Def. 1**, **2**, or **3** and press **INFO.** to create your custom Picture Style. On the **User Def.** menu screen select **Picture Style**. Turn ⟳ to find the preset you want to use as a starting point and then press (SET). Select one or more of the Picture Style parameters and alter it as required. Press MENU to return to the main Picture Style menu once you're finished.

There are a few good reasons to define your own Picture Style. The first is that it allows you to personalize your images—using the original presets is all very well, but it's not particularly creative.

Using a very subdued Picture Style—low in contrast and saturation—is also a good idea if you are shooting JPEGs and intend to heavily modify your images in postproduction. It's generally easier to add contrast and saturation than it is to remove them, and this applies even more strongly to sharpening. In fact, sharpening is almost impossible to remove once it's been applied to an image, so if you think you'll want to increase the resolution of an image later on (to make a large print, for example) set sharpening to 0. This will mean that you'll have to sharpen your images during postproduction, but they will be far easier to resize prior to that, without a visible drop in quality.

› Long exp. noise reduction

When making long exposures there's an increase in the level of visible noise in the resulting image—the longer the exposure, the greater the level of noise. The solution to this is to use a technique called "dark-frame subtraction" (the basis of the EOS 7D Mark II's **Long exp. noise reduction**). This requires two exposures to be made. The first exposure is the one that makes the image, while the second exposure is made for exactly the same length of time, but without the shutter opening. This second exposure should—theoretically—be completely black, but noise will add tonal variation to the image. The EOS 7D Mark II can use this tonal variation to work out where noise is occurring and then subtract it from the original exposure.

Options:
Enable (noise reduction is applied to every exposure of 1 sec. or longer); **Auto** (if the EOS 7D Mark II deems it necessary, noise

reduction will be applied to exposures of 1 sec. or longer); **Disable** (no noise reduction applied).

> **Note:**
> The drawback **to Long exp. noise reduction** is that your exposure times are effectively doubled. This can potentially make shooting long exposures a drawn-out affair, as you can't make other exposures until the noise reduction process is complete.

› High ISO speed NR

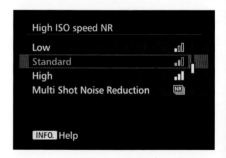

Noise can be an issue when high ISO values are selected. **High ISO speed NR** is Canon's solution to this and if you are shooting JPEGs, this is a better solution than waiting until postproduction.

However, high ISO noise reduction is better left until later if you are shooting Raw.

Options:
High (the maximum amount of noise reduction is applied, although this can also remove some of the fine detail in your images); **Standard**; **Low**; **Disable** (no noise reduction is applied, so if there is noise in your images you will need to tackle it during postproduction); **Multi Shot Noise Reduction** (your EOS 7D Mark II shoots four shots in quick succession and then merges them to produce the final image).

> *Notes:*
> **Multi Shot Noise Reduction** is only available when shooting JPEGs. It is a useful technique, but it will slow your camera down and restrict the use of other functions, such as flash and **B** You also can't use **Multi Shot Noise Reduction** when **Long exp. noise reduction** is set to **Enable**.
>
> As the camera needs to shoot four identical images to employ **Multi Shot Noise Reduction**, it's worth using a tripod so there's no camera movement between each shot.

› Highlight tone priority

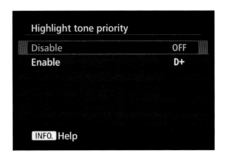

Highlight tone priority attempts to rescue highlights so they aren't overexposed, which can be beneficial when faced with high-contrast lighting.

Options:
Enable; Disable.

> *Notes:*
> **Highlight tone priority** has certain limitations: it cannot be used at the same time as Auto Lighting Optimizer; restricts the ISO range to 200–16,000; and can lead to increased noise in shadow areas.
>
> If you are shooting Raw, the effects of **Highlight tone priority** can be removed in postproduction, so it is best suited to JPEG capture.

To combat the effects of dust on the sensor, the EOS 7D Mark II automatically cleans the sensor every time you switch the camera on or off. However, there are certain types of foreign matter that can be trickier to remove. When this happens, the sensor will need to be cleaned manually, or dust marks will have to be dealt with during postproduction.

Dust Delete Data lets you shoot a reference image that's used to map the location of any dust on the sensor. This information is appended to subsequent images and DPP can use this to remove dust automatically from your images. However, it's not foolproof and you may find that important details in your images are removed at the same time.

Setting Dust Delete Data

1) Attach a lens with a focal length longer than 50mm to your EOS 7D Mark II. Switch the lens to manual focus and focus at ∞.

2) Aim your camera at a white surface—such as a sheet of paper—at a distance of approximately 12 inches (30cm). The white surface should fill the viewfinder entirely.

3) Select **Dust Delete Data** followed by **OK** (or **Cancel** to return to ◯ 3).

4) The EOS 7D Mark II will perform a sensor-cleaning sequence. When **Fully press the shutter-release button, when ready** is displayed, press the shutter-release button down. Once the Dust Delete Data image has been captured it will be processed. When **OK** is displayed press ⓈⒺⓉ. If the data is not obtained correctly, follow the instructions on screen and try again.

5) Once recorded successfully, you can shoot as normal: both JPEG and Raw files will have Dust Delete Data attached to them.

6) Switch on your computer, import any images shot after obtaining Dust Delete Data, and then launch DPP. Select one of your photographs in the main DPP window and click on the **Stamp** button. The image will redraw itself and any dust will be removed using the Dust Delete Data. Once this process is finished, click on **Apply Dust Delete Data**.

Notes:
If you don't use a clean white surface for your reference image, any blemishes on the surface may be mistaken for dust.

Dust Delete Data will slowly become out of date as you use your camera. Reshoot periodically, particularly if you're working in a dusty environment.

› Multiple exposure

Allows you to combine 2–9 exposures in one image. By default, **Multiple exposure** is set to **Disable**.

Options:
Disable: the default setting.

On: Func/Ctrl: allows you to check each individual image as you shoot and see how the shot images are blending together. As you shoot the sequence, ▣ will flash on the top LCD panel. After each shot you can press 🗑 to **Undo last image**, **Save and exit**, or **Exit without saving**.

On: ContShtng: allows you to see the results at the end, which enables you to shoot more quickly.

Multi-expos ctrl: controls the method used to blend the images. There are four further options: **Additive** (adds your exposures together—each image should be underexposed by ½-stop); **Average** (applies exposure compensation automatically); **Bright** (takes the brightest parts of the first image, compares each pixel in subsequent exposures, and blends only the brightest parts of each exposure to produce the final image); **Dark** (as **Bright**, but the darkest areas are blended).

No. of exposures: lets you determine the number of exposures that are merged.

Save source imgs: choose whether to save **All images** shot, or the **Result only**.

Continue Mult-exp: set whether you want to shoot **1 shot only**, or shoot multiple images **Continuously**.

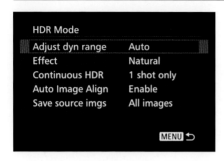

HDR Mode

Adjust dyn range	Auto
Effect	Natural
Continuous HDR	1 shot only
Auto Image Align	Enable
Save source imgs	All images

MENU ↩

The dynamic range of a camera refers to its ability to record usable detail in both the shadows and the highlights. Although the dynamic range of the EOS 7D Mark II is good, there will be times when the contrast is so high that you will have to compromise and lose detail somewhere at the extremes of the tonal range.

HDR is a technique that blends a number of frames taken at different exposures to produce a single, final image. **HDR Mode** on the EOS 7D Mark II blends three images shot in succession to create a final JPEG image. As you don't want the camera to move during the shooting sequence it's a good idea to use a tripod.

Options:

Auto image align: attempts to align the three source images. Choose **Enable** if shooting handheld; **Disable** if the camera is on a tripod.

Adjust dyn range: determines the exposure gap between the three shots; choose from **Auto** (the camera determines the exposure gap), **±1 EV**, **±2 EV**, or **±3 EV**. The greater the contrast range, the higher the value should be.

Continuous HDR: choose whether you shoot **1 shot only** or whether **Every shot** subsequently is HDR.

Effect: determines how the source images are merged. There are five further options: **Natural, Art standard, Art vivid, Art bold**, and **Art embossed** (see below).

You can choose to save **All images** shot as separate files (so that you can create an HDR in postproduction) or just the HDR merge by selecting **HDR img only**.

	Art standard	Art vivid	Art bold	Art embossed
Saturation	Average	High	Highest	Lowest
Bold outline	Average	Weak	Strong	Strongest
Brightness	Average	Average	Average	Darkest
Tone	Flat	Flat	Flat	Flattest

» SHOOTING 4 📷

› Red-eye reduc.

Sets the built-in flash and Speedlite (if attached) to reduce red-eye in portraits of people and animals. See chapter 5 for details.

› Interval timer

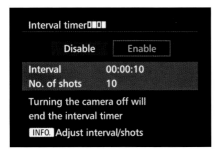

Allows you to automatically shoot a number of shots at regular intervals. This is useful for shooting images that you want to sequence together in video-editing software to produce a timelapse sequence, or for creating star trail images using multiple shots instead of long exposures.

Options:
No. of shots (choose to shoot 0–99 images); **Interval** (sets the time between exposures being made).

Notes:
The key to success with the Interval timer is to set a shutter speed that is faster than the **Interval** setting, as a slower shutter speed will result in fewer images than expected.

When **No. of shots** is set to **00**, the EOS 7D Mark II will continue to shoot until you physically stop the camera from shooting.

› Bulb timer

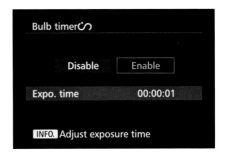

Allows you to set an exact length of time for your **B** exposures.

› Anti-flicker shoot.

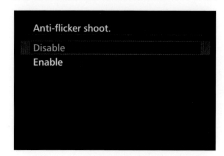

› Mirror lockup

Counters the flickering of fluorescent light sources to avoid potential exposure issues.

Options:
Disable (default); **Enable** (the camera will automatically sense the rate of flicker and only fire the shutter when the fluorescent lighting is at its maximum intensity).

Locks the reflex mirror up before making an exposure, which negates any vibrations that might affect image sharpness.

Options:
Disable (default); **Enable** (pressing the shutter-release button once will lock the mirror into the "up" position. Pressing the shutter-release button a second time will make the exposure and return the mirror to the down position).

> ***Note:***
> When you use **Mirror lockup**, the view through the viewfinder is blocked when the mirror is raised. This means it is only suitable when you are using a tripod and there's no chance that your composition will change accidentally.

» SHOOTING 5 📷

› Live View shoot.

Lets you set whether you can use Live View or not. There's no real advantage to disabling Live View, other than preventing it from being activated accidentally and wasting battery power.

Options:
Disable; Enable.

› AF method

Sets the AF method when using Live View. See pages 44–45 for details.

› Continuous AF

Sets the continuous focus mode for Live View shooting.

Options:
Disable (default); **Enable** (the EOS 7D Mark II will constantly adjust focus during Live View shooting, so when you take a shot the focus will be correct or need only a minor adjustment. However, constantly driving the AF motor in the lens drains the camera's battery more quickly).

› Grid display

› Aspect ratio

Lets you choose one of three different types of grid that can be overlaid on the LCD during Live View to aid composition or provide a visual check that elements in the scene are straight.

Options:

3x3 ⊞ (divides the screen using two vertical lines and two horizontal lines. This creates a grid that can help you compose using the "Rule of Thirds"); **6x4** ⊞ (divides the screen into 24 squares, which is useful when shooting architectural subjects that need to be square to the camera); **3x3+diag** ✳ (adds two diagonal lines running from the top to bottom corners to the standard 3x3 grid); **Off**.

The aspect ratio of an image is the ratio of the width of the image to its height. The EOS 7D Mark II's sensor has a 3:2 aspect ratio sensor, but you can also shoot using a different aspect ratio (see above right). When an aspect ratio other than 3:2 is selected, black borders are added to the Live View image to show how the image will be cropped after shooting.

> *Note:*
> Only JPEG images are recorded with an aspect ratio other than 3:2. Cropping information is appended to the Raw file, which can then be used by DPP to allow automatic cropping in postproduction (or it can be ignored).

Image quality	Aspect ratio and resolution (pixels)			
	3:2	4:3	16:9	1:1
L / RAW	5472 x 3648	4864 x 3648	5472 x 3072	3648 x 3648
M	3648 x 2432	3248 x 2432	3648 x 2048	2432 x 2432
M RAW	4104 x 2736	3648 x 2736	4104 x 2310	2736 x 2736
S1 /S RAW	2736 x 1824	2432 x 1824	2736 x 1536	1824 x 1824
S2	1920 x 1280	1696 x 1280	1920 x 1080	1280 x 1280
S3	720 x 480	640 x 480	720 x 408	480 x 480

› Expo. Simulation

Lets you see a reasonable representation of your final image before exposure.

Notes:
One aspect of exposure that **Expo. Simulation** can't emulate is the effect of a long shutter speed on a moving subject.

The LCD will darken when **Enable** is set and you underexpose. The more you underexpose the darker the LCD will get, to the point where you may not be able to see your subject clearly.

Options:
Disable (the Live View display remains at a constant brightness); **Enable** (the brightness of the Live View display will reflect the exposure settings you use); **During** 🔆 (you can choose to see the simulated exposure by pressing the depth of field preview button).

› Silent LV shoot.

Allows you to muffle camera noise when using Live View.

Options:
Disable (default); **Mode 1** (allows you to shoot continuously at a quieter level than normal); **Mode 2** (the shutter isn't re-cocked until you release the shutter-release button. This means that you can't shoot continuously, but you can leave the scene—keeping the shutter-release button pressed down—to find somewhere where the noise made by re-cocking the shutter won't disturb anyone).

› Metering timer

Sets the length of time that AE lock is held for, after it has been selected.

Options:
4, **8**, **16**, and **30 sec.**; **1**, **10**, and **30 min.**

» MOVIE SHOOTING 4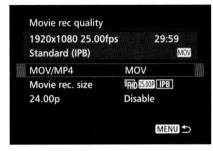

When you switch to Movie mode, the options on Shooting 4 ⬛ change from still photography options to movie options.

› Movie Servo AF

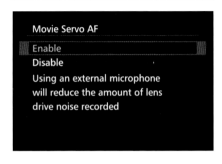

Activates continuous focusing during movie recording. However, unless you use an external microphone or one of Canon's new STM lenses there is a risk that you will record the noise of your lens' AF motor on your movie soundtrack (older, non-STM lenses can be particularly noisy).

Options:
Disable; Enable.

› AF method

Sets AF options for movie shooting, based on Live View AF. See pages 44–45.

› Movie rec quality

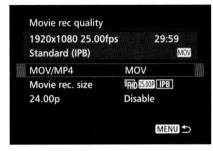

Allows you to set the resolution of your movies, the compression method, and the frame rate, as detailed in the grid on the following page.

File format

MOV	MOV is a proprietary format developed by Apple.
MP4	MP4 is an industry standard movie file format. The advantage over MOV is that it can be used more readily on different platforms (although it's relatively straightforward to convert from MOV to MP4 in postproduction).

Resolution

FHD (1920 x 1080)	Full HD recording with an aspect ratio of 16:9.
HD (1280 x 720)	HD recording with an aspect ratio of 16:9.
VGA (640 x 480)	Standard definition recording with an aspect ratio of 4:3. Suitable for analog TV and Internet use.

Frame rate

23.98P / 29.97P / 59.94P	For use in NTSC TV standard areas (North America/Japan).
25.00P / 50.00P	For use in PAL TV standard areas (Europe/Australia).
24.00P	For conversion to motion picture/film standard. Arguably, footage shot at 24 fps looks more natural, although there may be issues converting footage shot at 24 fps to 25 fps or 30 fps for standard HDTV broadcasting.

Compression

IPB	Compresses multiple frames using one keyframe stored approximately every ½ second (so that not every frame shot is ultimately recorded). This increases the efficiency of the compression, allowing more movie footage to be fitted onto a memory card.
ALL-I	Compresses each frame of movie footage individually. Less footage can be fitted onto a memory card, but the footage is more suitable for editing in postproduction.
IPB	Only available when **MOV/MP4** is set to **MP4**. **IPB** is a variation of **25** that achieves smaller movie file sizes by using a lower bit rate for data storage. It's less suitable for high-quality recording, but is excellent for general-purpose shooting.

› Sound recording

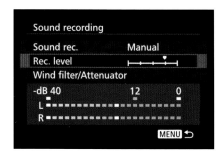

Allows you to set sound recording options.

Options:
Auto (the volume of the soundtrack is adjusted automatically as it is recorded); **Manual** (allows you to set the volume level from 1–64. After you've selected **Manual**, select **Rec. level**, and use ◄ / ► or the touchpad to set the volume); **Disable** (no sound will be recorded).

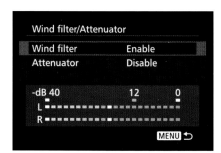

Wind filter: **Disable**; **Enable** (will try to eliminate wind noise during recording).

Attenuator: **Disable**; **Enable** (tries to reduce the effects of loud noises that may occur during movie recording).

› Movie Servo AF speed

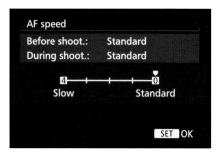

Provides control over the AF speed when shooting movies.

Options:
Disable; **Enable** (The **AF method** is set to FlexiZone **AF□**. If you have a USM lens produced after 2009 or an STM lens you can set the **AF speed** to **Slow** or **Standard**. You can also choose whether the **When active** AF speed is **Always on** or only **During shooting**).

> ## Movie Servo AF track sens.

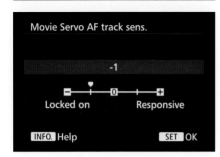

Sets how quickly the AF system tries to refocus if a moving subject is briefly obscured as they move behind other elements in a scene.

Options:
Locked on -2 or **-1** (the camera is less likely to refocus); **Responsive +1** or **+2** (the camera is more likely to refocus).

> *Note:*
> Movie Servo AF track sens. is only available when Movie Servo AF speed is set to **Enable**.

» MOVIE SHOOTING 5 📷

When you switch to Movie mode, the options on Shooting 5 📷 change from still photography options to movie options.

> ## Silent LV shoot.

See page 108 for details.

> ## Metering timer

See page 108 for details.

> ## Time code

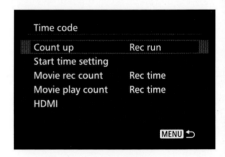

A **Time code** is a consistent sequence of numbers generated by a timing system. The EOS 7D Mark II has a built-in option to add a time code to the movie clips that you shoot, which can then be used as reference when you're editing, logging, or organizing clips. It's also invaluable when syncing sound to movie clips. The time code is recorded as hours, minutes, seconds, and frames.

Time code options

Count up	**Rec run** Time code counts up as you record a movie. **Free run** Time code counts up even when movie is not being recorded.
Start time setting	**Manual input setting** Lets you set the hours, minutes, seconds, and frames. **Reset** Time set by **Manual input setting** and **Set to camera time** is reset to 00:00:00:00. **Set to camera time** Sets hours, minutes, and seconds to the camera's internal clock.
Movie rec count	**Rec time** Shows the elapsed time from the start of movie recording. **Time code** Shows the time code during movie recording.
Movie play count	**Rec time** Shows the recording and playback time from the beginning of playback. **Time code** Shows the time code during playback.
HDMI	**Time code** If you record your movies externally via the HDMI connection you can choose whether the time code is exported (**On**) or not (**Off**). **Rec Command** Lets you set whether control over movie recording to an external device is synchronized with the device (**On**) or not (**Off**).
Drop frame	When the frame rate of a movie is set to 29.97P or 59.94P there can be a discrepancy between the length of the movie and the recorded time code. If you set **Drop frame** to **Enable** this discrepancy is corrected by the frames being dropped. Use **Disable** if you don't want time code correction applied.

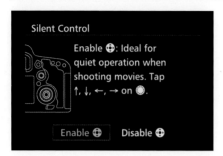

Silent control is highly recommended when shooting movies, particularly if you are relying on the EOS 7D Mark II's built-in microphone.

Options:
Disable; **Enable** ⊕ (you set movie functions during recording by touching the ⊕ touch pad, rather than turning ◯).

Tips

An alternative to using the EOS 7D Mark II to record sound is to use an external audio recorder. If placed carefully these will be free of noise generated by the camera or even you, the camera operator. The downside to using an audio recorder is that the soundtrack must be synchronized precisely with the video track in postproduction.

Keep your movie soundtrack simple. Too many different noises, particularly when simultaneous, will prove confusing.

Controllable functions	Shooting mode				
	Ⓐ⁺	P/B	Tv	Av	M
Shutter speed	–	–	Yes	–	Yes
Aperture	–	–	–	Yes	Yes
ISO	–	–	–	–	Yes
Exposure compensation	–	Yes	Yes	Yes	Yes
Sound recording level	–	Yes	Yes	Yes	Yes
Headphone level	Yes	Yes	Yes	Yes	Yes

› 🔘 btn function

› HDMI output + LCD

Sets the function of the shutter-release button (when pressed halfway down or fully down) during movie recording.

Setting	Half pressed	Fully pressed
⊡AF/🖸	Metering and AF	Still image shooting
⊡/🖸	Metering only	Still image shooting
⊡AF/'🎥	Metering and AF	Start/stop movie recording
⊡/'🎥	Metering only	Start/stop movie recording

Determines how the LCD screen is used when movies are being recorded to an external HDMI device.

Options:
No mirroring (the LCD screen on the camera does not show the movie as it is recorded. All information, such as the focus point, is overlaid on the external device's screen, if one is fitted); **Mirroring** (you can view the movie on both the EOS 7D Mark II's rear LCD screen and on the external device).

› Silent control

AF config. tool is the first screen you should study in order to customize the EOS 7D Mark II's complex AF system to your needs. There are three options that need to be taken account of: AI Servo tracking sensitivity (**Tracking sensitivity**), tracking speed changes (**Accel./decel. tracking**), and AF point automatic switching (**AF pt auto switching**).

Options:
Tracking sensitivity: sets the speed with which the AF system switches to another subject if the new subject moves across the active AF point(s). When **Tracking sensitivity** is set to a positive value the AF system will refocus the lens more rapidly; if **Tracking sensitivity** is set to a negative value, so that it's more resistant to change, it is less likely to focus away from your original subject.

Accel./decel. Tracking: sets how sensitive the AF system is to sudden acceleration or deceleration in the speed of your subject. Subjects that move at a constant speed, without excessive acceleration or deceleration, don't require the AF system to work as hard, so a value of **0** is all that's generally required.

However, some subjects—wildlife, for example—can speed up or slow down in an erratic manner, so **Accel./decel. tracking** would be better set to the maximum value of **2**. If you set the value too low, you may find the AF system "overshoots" if your subject stops suddenly.

AF pt auto switching: sets the readiness of the AF system to switch to different AF points as your subject moves around the AF area (this requires the use of an AF option that uses multiple AF points, such

as **Auto selection: 65 pt AF**). Use the maximum value of **2** for subjects that may move erratically around the viewfinder. The drawback to using a large value is that the AF system can feel too "twitchy" with slower, less erratic subjects.

Canon has included six preset case studies for the **AF config. tool** screen as outlined below. Each case study sets the three variables outlined above to suit a particular situation. You can customize each of these case studies to suit your shooting needs: to alter a case study turn ⚙ to highlight it, press RATE, and then turn ⚙ to highlight the required variable. Press (SET) and then turn ⚙ to make your adjustment. Press (SET)

to save the changes or MENU to return to **AF** 1 without saving. Pressing 🗑 will restore the default settings.

> **Note:**
> The AF menus are hidden when shooting in Ⓐ mode.

Case	Icon	Description
1	🏃	Multi-purpose setting.
2	🚶	Maintains tracking on subject, ignoring any obstacles.
3	🚴	Focuses instantly on subjects suddenly entering AF area.
4	🤾	For subjects that tend to suddenly accelerate or decelerate.
5	🤸	For erratic subjects moving in any direction.
6	⛹	Designed for subjects that change speed or move erratically.

3 » AUTO FOCUS 2 AF

› AI Servo 1st image priority

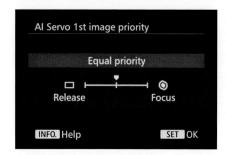

Allows you to prioritize between shutter release and focus for the first image taken when using AI Servo.

Options:
Equal priority (default setting—there is no bias to either the shutter release or focus); **Release priority** (the exposure will be made immediately after the shutter-release button has been pressed, regardless of whether focus has locked); **Focus priority** (the shot will not be taken until focus has been locked on the subject).

› AI Servo 2nd image priority

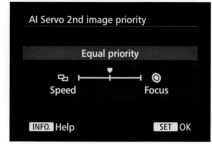

Lets you decide whether shooting speed or focus for the second image is more important when using AI Servo.

Options:
Equal priority (default setting—there is no bias to either the shutter release or focus); **Shooting speed priority** (the shooting speed will be maintained at the expense of focus accuracy); **Focus priority** (the EOS 7D Mark II will make you wait until focus has been locked on the subject before the shot is taken).

» AUTO FOCUS 3 AF

› Lens electronic MF

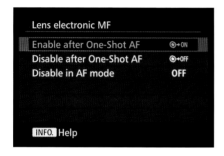

If you attach one of the lenses listed below to your EOS 7D Mark II you can choose whether or not it can be focused manually (even when the focus switch on the lens is set to AF).

Options:
Enable after One-Shot AF (you can focus manually after the AF system has focused the lens, but only if you keep the shutter-release button pressed down halfway); **Disable after One-Shot AF** (the lens cannot be focused manually once focus has locked); **Disable in AF mode** (prevents you from focusing manually unless the lens is physically set to MF).

Compatible lenses

EF-S 10–18mm f/4.5–6.3 IS STM	EF-S 18–55mm f/3.5–5.6 IS STM	EF-S 18–135mm f/3.5–5.6 IS STM
EF 28–80mm f/2.8–4L USM	EF 40mm f/2.8 STM	EF 50mm f/1.0L USM
EF-S 55–250mm f/4–5.6 IS STM	EF 85mm f/1.2L USM	EF 85mm f/1.2L II USM
EF 200mm f/1.8L USM	EF 300mm f/2.8L USM	EF 400mm f/2.8L USM
EF 400mm f/2.8L II USM	EF 500mm f/4.5L USM	EF 600mm f/4L USM
EF 1200mm f/5.6L USM		

› AF-assist beam firing

› One-Shot AF release prior.

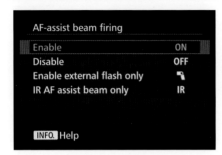

The AF system may struggle in low light—this menu option allows you to set whether the AF-assist beam supplied by the built-in flash or attached Speedlite activates or not.

Options:
Disable; **Enable** (AF-assist lamp activates if necessary); **Enable external flash only** (only enables the AF-assist lamp on an external flash—the built-in flash is always ignored); **IR AF assist beam only** (uses the invisible infrared AF-assist beam available on certain Speedlite models).

Allows you to choose whether the camera prioritizes shooting speed or focus when using One-Shot AF.

Options:
Release (the shutter will fire regardless of whether focus has locked or not); **Focus** (the shutter will only fire when focus has been achieved).

› Lens drive when AF impossible

Determines what happens if the lens tries to focus and fails.

Options:
Continue focus search (lens will continue trying to achieve focus); **Stop focus search** (the EOS 7D Mark II will stop focusing if focus lock proves elusive).

> **Note:**
> When your camera struggles to get a focus lock, switch the lens to MF and try to get the focus as close as you can. Then, switch the AF back on to refine the focusing.

› Selectable AF point

Allows you to restrict the number of selectable AF points when manually selecting AF points.

Options:
65 points; **21 points**; **9 points** (widens the gap between the available AF points, increasing the possibility that your subject will fall between the AF points, but speeds up the time it takes to cycle around the available AF points).

› Select AF area selec. mode

Allows you to limit the AF area selection choices you have. You can select one, all, or a mixture of the available settings.

Options:
Manual selection: Spot AF; Manual selection: 1 point AF; Expand AF area; Expand AF area: Surround; Manual select.: Zone AF; Manual select.: Large Zone AF; Auto selection: 65 pt AF.

› AF area selection method

Allows you to choose how the AF area is selected.

Options:

 ➤ **M-Fn button** (default setting—the AF area is selected by pressing ⊞ followed by repeated presses of the M-Fn button or pushing 🕹); ⊞ **Main Dial** (the AF area is selected by pressing ⊞ followed by turning ➰ or pushing 🕹).

› Orientation linked AF point

Allows you to determine whether the orientation of the camera affects the AF point(s) or AF zones.

Options:

Same for both vert/horiz (the same AF point(s) or AF zone is used whether your EOS 7D Mark II is held vertically or horizontally); **Separate AF pts: Area+pt** (the AF area and AF points can be set separately for three camera orientations: horizontal, vertical with the camera grip to the bottom, and vertical with the camera grip to the top); **Separate AF pts: Pt only** (only the AF points will be set separately for the three camera orientations).

› Initial Afpt, ◌ AI Servo AF

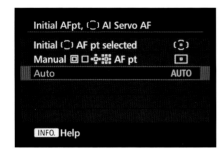

Sets the initial AF point selection in AI Servo AF mode.

Options:
Initial ⠿ AF pt selected (default setting—when you switch to AI Servo AF and the AF area selection mode is set to **Auto selection: 65 pt AF**, this sets the initial AF point to the AF point you manually selected previously); **Manual ⊡** ⬚ ⠿⠿ **AF pt** (sets the initial AF point to the AF point you manually selected, before switching to **Auto selection: 65 pt AF**); **Auto** (lets the EOS 7D Mark II decide where to set the initial focus point).

› Auto AF pt sel.: EOS iTR AF

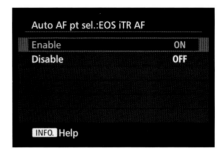

Determines whether the camera's AF uses Intelligent Tracking and Recognition (iTR).

Options:
Disable; **Enable** (the AF system detects faces automatically and focuses on those. It can also detect color and will track subjects based on the color detected when the lens focuses initially).

> **Notes:**
> **Auto AF pt sel.: EOS iTR AF** can only be enabled when **AF area selection** is set to **Zone AF, Large Zone AF**, or **65 pt AF**.
>
> The processing involved with **Auto AF pt sel.: EOS iTR AF** reduces ⩲ₕ shooting to 9.5 fps.

3 » AUTO FOCUS 5 AF

› Manual AF pt. selec. pattern

Allows you to determine manual AF point selection behavior.

Options:
Stops at AF area edges (when you reach the edge of the AF frame area, selection stops); **Continuous** (allows AF point selection to "jump" to the opposite side of the AF frame, from far left to far right, or top to bottom, for example).

› AF point display during focus

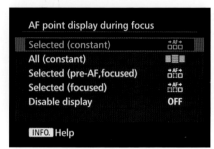

Used to customize how the AF points are shown in the viewfinder.

Options:
Selected (constant) (displays the selected AF point(s) or zones both before and after focusing); **All (constant)** (displays all of the AF points, regardless of whether they are selected or not); **Selected (pre-AF, focused)** (the AF points are displayed when you select them, before you begin to focus, and when focus is locked); **Selected (focused)** (the AF points are only displayed when you select them, and when the camera locks focus); **Disable display** (will only display the AF points when you choose them. After that they will not be displayed, even when focus is locked).

› VF display illumination

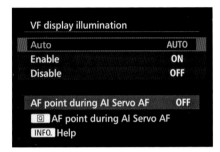

Determines whether the AF points and grid light red in the viewfinder when focus is achieved.

Options:

Disable (AF points and grid do not light); **Enable** (AF points and grid light red when focus is achieved); **Auto** (AF points and grid only light when focus is achieved and the ambient light is low).

› AF status in viewfinder

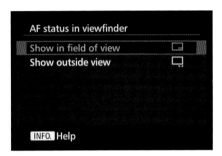

Allows you to set where the AF status icon is displayed in the viewfinder.

Options:

Show in field of view (the AF indicator is displayed in the main image area of the viewfinder); **Show outside view** (the AF indicator is moved below the ● focus confirmation light in the information strip at the bottom of the viewfinder).

› AF Microadjustment

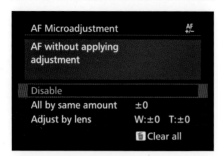

AF Microadjustment allows you to correct for back focus (when the AF system focuses slightly behind the intended focus point) or front focus (when the AF system focuses slightly forward of the intended focus point). Up to 40 lenses can be corrected, and each time you fit an adjusted lens any back focus or front focus problem is automatically compensated for.

The difficulty with adjusting the AF is knowing how much adjustment is needed. Fortunately, there are several tools available that will help enormously. The first that is worth mentioning is free and can be viewed at photo.net/learn/focustest.

The second tool, called LensAlign, is a commercial solution created by Michael Tapes Design, and is available from www.michaeltapesdesign.com.

» PLAYBACK 1 ▶

› Protect images

Set or unset protection on images to avoid accidental erasure. See page 58 for details.

› Rotate image

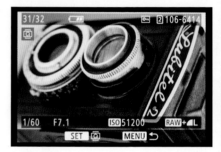

Allows you to rotate an image. To do this, navigate to the image and press ⬛ to rotate the image 90° clockwise. Press ⬛ again to rotate a further 180°. Pressing ⬛ a third time restores the image to its original orientation. To rotate further images turn ⬤ and repeat the process.

› Erase images

Select and erase unprotected single images, or all images in a folder or on a memory card. See page 57 for details.

› Print order

Sets the print order for your images to control how they are printed when your camera is connected to a PictBridge printer or when the memory card is taken to a photo lab for image printing. See chapter 8 for more information.

› Photobook Set-up

Allows you to select up to 998 JPEG images to use in a photobook. Once you've made the selection, EOS Utility can be used to transfer the images to a dedicated folder on your computer's hard drive.

The procedure for choosing images is very similar to choosing images for protection, as outlined on page 58. You can: **Select images**; **All images in folder**; **Clear all images in folder**; **All images on card**; **Clear all images on card**.

Note:
Raw files cannot be added to your Photobook selection.

› Image copy

Lets you copy single images, groups of images, or folders of images between two memory cards installed in your EOS 7D Mark II. This is useful if you want to backup a memory card, or need to supply images to someone on a different type of memory card than the one you've used.

Your EOS 7D Mark II has a built-in image processor that allows you to convert Raw files to JPEGs. The tool isn't as well specified as most Raw conversion software, but it is very useful if you really, really need a JPEG in a hurry.

Converting Raw files
1) Select **RAW image processing**.

2) Find the Raw file you wish to convert (JPEGs will not be displayed) and press (SET).

3) Use ✣ to highlight the required image adjustment tool and then turn ♒ to cycle through the various options for that tool. To view a more detailed adjustment screen press (SET); turn ◯ to highlight the required adjustment as required and then press (SET) to select the adjustment and return to the main **RAW image processing** screen.

4) Highlight ◢**L Image quality** and turn ♒ to adjust the quality of the final JPEG.

5) Select ⬒ once you're happy with your adjustments. Select OK to save the JPEG, or **Cancel** to return to the **RAW image processing** screen to make further alterations to your image.

Symbol	Image adjustment
☀±0	Adjusts image brightness by ±1 stop in ⅓-stop increments.
sRGB	Sets color space.
☁AWB	Alter white balance using presets or a Kelvin value.
☐OFF	Applies peripheral illumination correction.
☁P-S	Sets Picture Style.
▨OFF	Corrects lens distortion.
▣OFF	Applies Auto Lighting Optimizer.
⁄⁄OFF	Chromatic aberration correction.
NR▮	High ISO speed noise reduction.
◢L	JPEG image quality.

› Resize

Note:
You cannot increase an image's size (although this can be done in postproduction if necessary).

Resize lets you shrink your JPEG images, saving the smaller image as a new file. However, the smaller the original image, the fewer options you have to make it smaller still, as shown in the grid below.

Original size	Sizes available for resizing			
	M	S1	S2	S3
L	Yes	Yes	Yes	Yes
M	–	Yes	Yes	Yes
S1	–	–	Yes	Yes
S2	–	–	–	Yes
S3	–	–	–	–

› Rating

Allows you to tag your images with one to five stars (★) or no stars (**Off**; the default for every image you shoot). See page 56 for more information about rating images.

Changing the rating
1) Select **Rating**.

2) Turn ○ to skip through the images on the memory card.

3) When you reach an image you want to add a rating to press ⑤. Press ▲ / ▼ to decrease or increase the rating and press ⑤ to set that rating.

4) Turn ○ to select other images for rating and repeat step 3.

5) When you're finished, press MENU to return to the ▶ 2 menu screen.

› Slide show

Lets you view a sequence of images shot with your EOS 7D Mark II. This can either be viewed on the LCD, or on a TV for more impact. Both Raw and JPEG images can be added to a slide show, as well as movies.

Setting up a slide show
1) Select **Slide show**.

2) Select ▣ **All images**. Press ▲ / ▼ to change this to ▦ **Date**, ▆ **Folder**, '▖ **Movies**, ▢ **Stills**, ⊶ **Protect**, or ★ **Rating** as required.
When ▦ **Date**, ▆ **Folder**, or ★ **Rating** is selected you can view and alter the options for these functions by pressing **INFO.** The images displayed during the slide show are filtered according to the choices that you make at this stage. Press ⑤ when you're finished.

3) Select **Set up**, followed by **Display time** to alter the length of time each still image

› Image transfer

remains on screen. Set **Repeat** to either **Enable** or **Disable** depending on whether you want your slide show to repeat after completion. Press MENU to return to the main Slide show screen.

4) Select **Start** to start the slide show.

5) To pause and restart your slide show press (SET). Press MENU to stop the slide show and return to the main Slide show options screen.

> **Note:**
> The images in the slide show will be displayed according to how you have playback set up. Press **INFO.** to change the display mode during the slide show if required.

Allows you to select specific images (or groups of images) to transfer to your computer using EOS Utility. If you've shot Raw+JPEG you can also specify whether the JPEGs, Raw files, or both are transferred.

› Image jump w/🔄

Allows you to set how your EOS 7D Mark II skips through images when turning 🔄 during playback. This becomes more important the greater the number of images you have saved on the memory

card. The rating option is particularly useful, as it can be used to classify and group types of images together (such as landscapes or portraits).

Symbol	Description
1	Display one image at a time.
10	Jump 10 images at a time.
100	Jump 100 images at a time.
☉	Skip through images by date.
⬚	Skip through images by folder.
🎬	Skip through movies only.
📷	Skip through still images only.
⊶	Only skip through protected images.
★	Skip through images by rating.

Note:
If you have not rated any of your images you cannot use ⛭ to jump through them.

» PLAYBACK 3 ▶

› Highlight alert

Provides you with a simple and useful way of determining if parts of an image are overexposed.

Options:
Disable; **Enable** (highlights that have blown out to white will blink).

Note:
Highlight alert is arguably more useful when shooting JPEGs, as Raw files allow you to recover highlight detail during postproduction.

› AF point disp.

Determines whether the AF points that were used to achieve focus are shown over the currently viewed image.

Options:
Disable; **Enable** (AF points overlaid on image).

› Playback grid

Allows you to display the same grid patterns over your images in playback as you can overlay when using Live View (see page 106).

Options:
Off; 3x3 ⌗; 6x4 ⫴⫴; 3x3+diag ⌗⤬.

› Histogram disp

› Movie play count

Determines which type of histogram is shown when detailed shooting information is viewed in playback mode.

Choose what information is shown during movie playback.

Options:
Brightness (shows brightness histogram); **RGB** (shows individual histograms for red, green, and blue channels).

Options:
Rec time (the basic length of the movie in minutes and seconds); **Time code** (see page 112–113 for more information about time codes).

› Magnificatn (apx)

Allows you to choose the initial image magnification and starting point when Q is pressed in playback.

Options:
1x (no magnification) (displays the entire image on the LCD); **2x (magnify from center)**; **4x (magnify from center)**; **8x (magnify from center)**; **10x (magnify from center)**; **Actual size (from selected pt)** (displays the image at 100%. The starting point is determined by the AF point used to achieve focus or if MF was used, the image is displayed at 100% from the center); **Same as last magnif. (from ctr)** (displays the image using the last magnification factor used when the magnified view was exited by pressing Q or ▶).

› Ctrl over HDMI

Allows you to use a TV's remote control to operate some of the EOS 7D Mark II's playback functions (when the camera is connected to a CEC HDMI-compatible HDTV via HDMI).

Options:
Disable; Enable.

› Record func+card/folder sel.

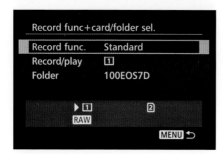

If you have two memory cards in your camera, you need to decide what files are stored on which card. You may also want to create your own folders on your memory cards—to differentiate separate shooting sessions, for example.

Options (when you select **Record func**): **Standard** (images and movies are stored on the selected card only and swapping to other card is achieved manually); **Auto switch card** (the camera will switch automatically from the first memory card to the second, once the first card is full); **Rec. to multiple** (images and movies are recorded to both cards simultaneously); **Rec. separately** (Raw files are written to one card and JPEGs to the other).

Options (when you select **Folder**): **Create Folder** (creates a new folder using a three-number system starting at 100 and continuing up to 999. The numbers are followed by the word "EOS7D." You can also select the name of the folder that you want to use (the EOS 7D Mark II will save all subsequent images and movies shot into this folder until you choose or create a new folder).

Setting up
1) Select **Record func+card/folder sel.**

2) Select **Record func.**, highlight your required option, and press ⓢⒺⓉ.

3) If you choose **Standard** or **Auto switch card** you also need to select the primary memory card. On the **Record func+card/folder sel.** menu select **Record/play** and then select either the CompactFlash card ⟦1⟧ or SD card ⟦2⟧. If you select **Auto switch card**, the primary card will be used first until it is full.

4) If you selected **Rec. separately** or **Rec. to multiple** you will also need to select **Playback** to choose which card is used for image playback.

Notes:
When **Auto switch card** is selected and the EOS 7D Mark II switches memory cards (when the first card is full), a new folder is created.

Only 999 folders can be created on a memory card.

› File numbering

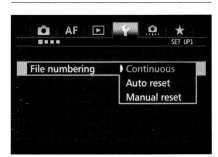

Every time a file is written to the memory card it is assigned a file name. The last four characters before the file type suffix are numbers—a count of the number of images you've created, starting at 0001.

Options:
Continuous (the count continues up to 9999 and then reverts to 0001, even if you

use multiple folders and memory cards); **Auto reset** (forces the count to be reset to 0001 every time an empty memory card is used); **Manual reset** (a new folder is created on the memory card and the count is reset to 0001).

Note:
Folders can only store 9999 images. Once this limit is reached, a new folder is automatically created and images are written to this new folder. The exception to this is when there are 9999 images in folder 999—you will not be able to use that memory card until it has been emptied.

› File name

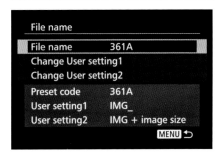

By default, the first four characters of an image file name are alphanumeric

characters that are unique to your camera (assigned at the time of manufacture). You can, however, change these characters:

Options:
IMG_; **IMG + image size**; four characters of your own choosing.

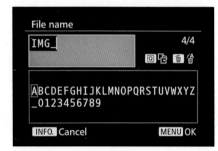

Changing the file name convention: setting 1

1) Select File name.

2) Select **Change User setting 1**. By default, the first four characters are set to **IMG_**. Press 🗑 to delete these characters and then press Q to jump down to the character entry box below.

3) Turn ⟳ to highlight the desired character and press (SET) to select it. Repeat until you've added your four characters. If you make a mistake press 🗑.

4) When you are finished, press MENU to continue, or press **INFO.** to return to

the main **File name** menu without saving the new settings.

Changing the file name convention: setting 2

1) Select **Change User setting 2**. By default, the first three characters are set to **IMG** (the fourth is reserved for use by the camera). Press 🗑 to delete the three characters and then press Q to jump down to the character entry box below.

2) Repeat steps 3 and 4, as outlined in *Changing the file name convention: setting 1* (left).

Notes:
If you create a folder on the memory card when it is connected to your computer it must use the same naming convention: the five-letter word can only use alphanumeric characters (a–z, A–Z, or 0–9) or an underscore "_." No other characters (including "space") are allowed.

When User setting 2 is selected, the fourth character changes depending on the image quality setting of the image. Using ◢L, ◣L, and RAW adds an "L;" ◢M, ◣M, and M RAW adds an "M;" ◢S1, ◣S1, and S RAW adds an "S;" S2 adds a "T;" and S3 adds a "U."

› Auto rotate

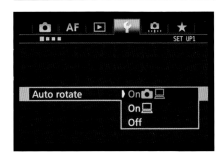

By default, vertical format images will be rotated on playback so they appear the "right way up." However, this means they will not fill the screen, so are much smaller and less easy to view than horizontal format images. You can change this using **Auto rotate**.

Options:
On 📷 🖥 (default setting—images are rotated automatically, as described above); **On** 🖥 (does not rotate the images when viewing them on the camera's LCD screen, but does rotate them so they are in the correct orientation when copied to your computer. You have to rotate your camera 90° to view vertical images in the correct orientation in playback); **Off** (does not rotate the images on either your camera or when copied to your computer).

› Eye-Fi settings

Used for Eye-Fi memory card control. Only visible when an Eye-Fi card is installed. See chapter 8 for more information.

Tip

*Set Auto Rotate to **On** 🖥 when shooting vertically on a tripod. This means you won't need to flip your camera out of position to view your image in the correct orientation. Moving your camera once it's set up on a tripod isn't a good idea; it's almost impossible to return to the right position afterward!*

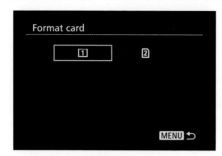

Most memory cards come pre-formatted, but it is advisable to format a memory card the first time it's used in your EOS 7D Mark II. This is particularly important if the memory card has been used in another camera previously, as any files saved by another camera may not be visible to the EOS 7D Mark II, so you may have less space on your card than you realize.

Formatting a memory card

1) Select **Format card**. If both memory card slots are occupied, turn ⊙ to highlight the memory card that you want to format. The CompactFlash card is shown by a ⓵ symbol; the SD card by ⓶. If only one memory card is fitted, the icon for that card will be highlighted; the other will be grayed out and inaccessible. Press ⑅ to continue.

2) Select **OK** to format the memory card or **Cancel** to return to the previous step.

3) As the card formats, **Busy...Please wait** will be displayed on screen. When the formatting process is complete, the camera returns to the ♥ 1 menu.

Note:
When you format the SD memory card you'll see a **Low Level Format** option. When a memory card is formatted, usually only the list of contents is erased. The original files are still on the memory card, but as the list of contents has been removed the camera can't "see" them. As you create more images, these leftover files are gradually overwritten, but if you accidentally format a memory card it is often possible to recover your files with file-recovery software, provided you don't use the card until then.

When you select **Low Level Format**, everything on the card is erased, not just the list of contents. This takes longer than a standard format, but is worth doing every so often, particularly if you shoot video. To use low level formatting press 🗑 when you first enter the Format screen at step 3. A ✓ will be displayed next to **Low Level Format** to show you've chosen this option.

» SET UP 2 ⚐

› Auto power off

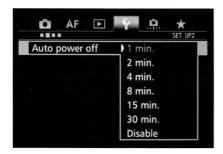

If you leave your EOS 7D Mark II untouched (without turning it off), it will eventually go to "sleep" to conserve power. **Auto power off** lets you set the length of time your camera waits until powering down. When the camera is asleep lightly pressing on the shutter-release button, MENU, **INFO.**, or ▶ will wake it.

Options:

1, **2**, **4**, **8**, **15**, or **30** minutes; **Disable** (the camera will not power down, although the LCD will switch off after 30 minutes of inactivity, or if you press **INFO.**).

› LCD brightness

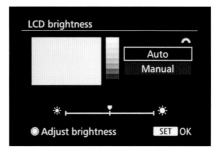

Allows you to determine the brightness of the rear LCD screen.

Options:

Auto (the camera uses the light sensor on the back of the camera to measure the ambient light and adjust the brightness of the rear LCD screen so that it's easy to see); **Manual** (turn ⊙ to set the brightness of the LCD between 1/darkest and 7/brightest. Ideally, you should be able to distinguish all eight of the gray bars shown at the center of the LCD screen).

> **Note:**
> Don't use the LCD screen as a guide to the exposure of your images. A better—and far more objective—method is to use the histogram in Live View or playback.

› Date/Time/Zone

Allows you to set the correct date, time, and time zone. For details see page 28.

› Language

Sets the language used to display the menu and shooting options.

Options:
English; German; French; Dutch; Danish; Portuguese; Finnish; Italian; Ukrainian; Norwegian; Swedish; Spanish; Greek; Russian; Polish; Czech; Hungarian; Romanian; Turkish; Arabic; Thai; Simplified Chinese; Chinese (traditional); Korean; Japanese.

› Viewfinder display

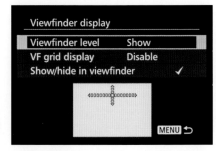

The viewfinder in your EOS 7D Mark II has a transparent LCD panel built into it, which allows you to switch on helpful information as needed.

Options:
Viewfinder level (adds a guide that shows how level your camera is); **VF grid display** (adds a fine 5 x 3 grid to the viewfinder); **Show/hide in viewfinder** (lets you choose between a variety of shooting function icons that can act as a useful visual reminder of your camera's current setting).

› GPS/digital compass settings

Settings that allow you to configure the EOS 7D Mark II's built-in GPS. See pages 234–236 for more details.

›› SET UP 3 ✿

› Video system

There are two main television standards in use around the world—if you want to connect your EOS 7D Mark II to a TV you should select the standard that is relevant for your location.

Options:
For NTSC (if you're shooting movies for use on North American and Japanese TVs);
For PAL (for European, Russian, and Australian TVs).

› Battery info.

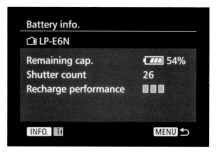

It always pays to have spare batteries, but batteries don't last forever—as they get older, they become less efficient. **Battery info.** allows you to register up to six LP-E6(N) batteries, so you can track their recharge performance history over time (every LP-E6(N) has a unique serial number that can be written onto a label and fixed to the battery).

A standard LP-E6(N) battery is rated for approximately 500–600 charge cycles. A full charge cycle is when 100% of the battery's power is used and then recharged. However, this doesn't mean the battery needs to be discharged completely before recharging—if you were to use 25% of the charge in the battery, recharge it, and repeat this a further three times, you would have completed one full charge cycle.

Recharging frequently this way—before reaching the point of complete depletion—

will also prolong the life of your battery, although if you find your battery does not hold power, it is likely it is coming to the end of its useful life. When the **Recharge performance** bar shows only one (red) bar, the battery should be replaced.

Battery info. also displays the **Shutter count** (the number of times the shutter has been fired since the last time the battery was recharged), and the **Remaining cap.** (the amount of charge left of the battery as a percentage).

> *Note:*
> A battery does not need to be in your camera for you to be able to check or delete its performance history.

Registering a battery

1) Select **Battery info.** and then press **INFO.**.

2) Select **Register**. Select **OK** to continue or **Cancel** to return to the start of this step.

3) Press MENU to return to the main **Battery info.** screen.

> *Note:*
> To delete registered battery information select **Delete** at step 2 instead of **Register**. Turn ◯ to highlight the battery you wish to delete and press ⊛ to continue.

› Sensor cleaning

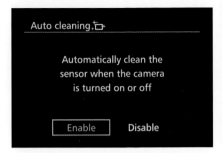

By default, the sensor is cleaned every time you switch your camera on or off, but you can override this with **Sensor cleaning**.

Options:

Auto cleaning: Disable (sensor is not cleaned at start up/shutdown, so your camera will be ready to shoot as soon as you switch it on); **Enable** (sensor cleaned automatically).

Clean now: forces a sensor clean without the need to turn the camera off and on.

Clean manually: raises the mirror and exposes the sensor to allow you to clean it manually with a sensor-cleaning kit. This should only be attempted with a freshly charged battery and only if you're confident that you know what you're doing—get it wrong and you could scratch the surface of the low pass filter, resulting in an expensive repair bill.

› RATE btn function

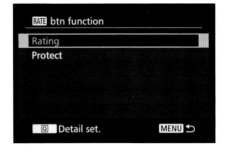

Note:
Dust becomes more prominent
the smaller the aperture you use.
Try to use the largest aperture you
can and focus precisely, rather than
using a small aperture and relying
on depth of field for sharpness.

RATE is a "soft" button, as you can change
its behavior when in playback mode.

Options:
Rating (give image a rating); **Protect**
(protect image).

› INFO. button display options

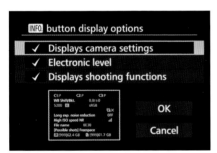

Determines the information displayed
on the rear LCD screen as you repeatedly
press **INFO.** in shooting mode.

Options:
Displays camera settings; Electronic
level; Displays shooting functions.

Allows you to specify the frame rate of an external recording device when exporting video data via the HDMI connection. The frame rate of a device will usually be found in its user manual.

Options:
Auto (the frame rate is set automatically, if this can be determined by the camera); **59.94i**, **59.94p**, and **23.9p** (if **Video system** is set to **For NTSC**); **50.00i** or **50.00p** (if **Video system** is set to **For Pal**).

» SET UP 4 ✿

› Custom shooting mode (C1–C3)

It's frustrating when you come to shoot a once-in-a-lifetime photograph and you fail because the camera was in the wrong mode. One of the EOS 7D Mark II's very useful tricks is the option to create up to three custom settings configured to different shooting situations.

If you regularly swap between different types of photography—such as sports/action and landscape—saving the relevant settings to two different custom modes will allow you to switch between the two styles quickly and painlessly.

Setting a Custom shooting mode
1) Configure your camera as required, setting the shooting mode (and metering mode if relevant), drive mode, exposure compensation, ISO speed, and so on. This includes a useful number of the menu options too.

2) Press MENU and select **Custom shooting mode (C1–C3)**.

3) Select **Register settings**.

4) Select the Custom shooting mode that you wish to assign the settings to (**C1**, **C2**, or **C3**). Select **OK** to continue.

5) Press down lightly on the shutter-release button to return to shooting mode and turn the mode dial to the Custom shooting mode number you selected at step 4.

Notes:
To erase your settings, select **Clear settings** on the Custom shooting mode (C1–C3) screen. Select the Custom shooting mode you wish to erase, followed by **OK**.

When **Auto update set.** is set to **Enable**, any changes you make to the EOS 7D Mark II's shooting functions when using C1, C2, or C3 will be applied automatically to that Custom shooting mode.

› Clear settings

Resets camera to factory default settings. There's no going back, so think carefully before you proceed!

CUSTOM OPTION ≫
If you regularly shoot landscapes, you could set one Custom mode to **Av**, with an aperture setting of f/8 or f/11. This means it will take less time to set up when you reach a location.

The copyright of every image you shoot belongs to you (see the note below for exceptions). Your camera can be set to add copyright details automatically to every image you shoot.

Setting Copyright information
1) Select **Copyright information**.

2) Select either **Enter author's name** or **Enter copyright details**.

3) On the text entry page press [Q] to jump between the text entry box and the rows of alphanumeric characters below. Turn ◯ or press ✛ to highlight the required character and then press (SET) to add it to the text entry box above. Continue to add characters to build up the relevant copyright information. If you accidentally enter in the wrong character, press 🗑 to delete it.

4) Press MENU and select **OK** when you've completed the text entry to save the details and return to the main Copyright information menu. Alternatively, press **INFO.** and select **OK** to return to the main screen without saving.

Other Copyright information settings
Display copyright info. displays the currently set copyright information. If no copyright information is set, the option is grayed out and cannot be selected.

Delete copyright information removes the copyright information set on the camera (but not from the metadata of any images already saved on the memory card). Again, if no copyright information is set, the option is grayed out and cannot be selected.

Note:
It's likely that you'll set the same information in **Enter author's name** and **Enter copyright details**. However, you can assign copyright in an image (or any created work) to anyone you wish. In this instance you would set another person's name or even a company (if you were shooting images as an employee) as the copyright owner.

› Firmware Ver.

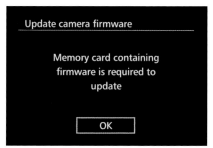

Behind the scenes, every digital camera uses built-in software, or "firmware," to make sure that everything runs smoothly. However, no firmware is entirely free of problems. At the time of writing there are no reported issues with the EOS 7D Mark II, but that doesn't mean there aren't any waiting to be discovered. If this happens

then Canon will occasionally release new firmware to cure any bugs.

Firmware is also sometimes released that radically improves a camera—for example, Canon breathed new life into the original EOS 7D and added new features by overhauling its firmware.

Canon will announce on its web site when an update to the firmware is available, as well as by email to registered users. Full instructions on how to update your camera will be included with the firmware update. If you're not confident about updating the firmware you can also have it updated at a Canon Service Center—although you will be charged a fee for the privilege.

› Certification Logo Display

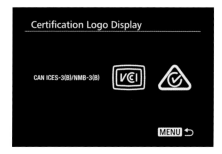

Certification Logo Display shows the third-party imaging technology that Canon licensed for use in the EOS 7D Mark II. This is irrelevant to how you use your camera, so **Certification Logo Display** is an option you may look at once and never view again.

3 » CUSTOM FUNCTIONS 1

› Exposure level increments

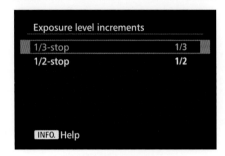

Allows you to set the increment level for exposure operations such as shutter speed, exposure compensation, and so on.

Options:
1/3-stop; 1/2-stop.

> **Note:**
> It will be less easy to set a precise exposure if you choose **1/2-stop**, but exposure selection will be slightly faster as there is a smaller range of options to skip through.

› ISO speed setting increments

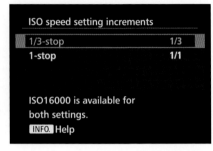

Determines the increment level for ISO speed adjustment.

Options:
1/3-stop; 1-stop.

› Bracketing auto cancel

Determines whether exposure and white balance bracketing is cancelled automatically.

Options:
Disable (bracketing will not be cancelled, even when you switch your camera off, although it will be cancelled temporarily if you switch to movie shooting or when a Speedlite is set to fire); **Enable** (bracketing will be cancelled when your camera is switched off, when you switch to movie shooting, and when an attached Speedlite is switched on).

› Bracketing sequence

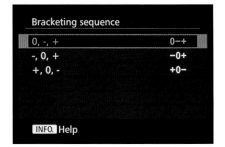

Sets the order in which exposure and white balance bracketed sequences are shot.

Options:

0,-,+ (default setting. The "correct" image is shot first, followed by the negatively adjusted image, then the positively corrected image); **-,0,+** (the bracketed sequence is set to negative, correct, positive); **+,0,-** (the bracketed sequence is set to positive, correct, negative).

› Number of bracketed shots

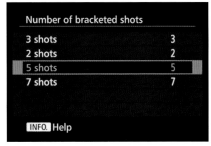

Sets the number of shots in a bracketed exposure or white balance sequence.

Options:

3 shots (default); **2 shots**; **5 shots**; **7 shots** (useful if you are bracketing to produce HDR images in postproduction).

› Safety shift

› Same expo. for new aperture

Helps avoid under-/overexposure when using **P**, **Tv**, and **Av** modes.

Options:
Shutter speed/Aperture (the selected exposure setting in **Tv** and **Av** modes will be adjusted automatically if the scene brightens or darkens to the point that the required exposure falls outside the possible exposure range); **ISO** (the manually selected ISO setting in **P**, **Tv**, and **Av** modes will be altered automatically to achieve the same result); **Disable** (under- or overexposure may result if the brightness of the scene can't be adjusted for).

Lenses vary in their aperture range. When using **M**, switching lenses or zooming may mean that the aperture you selected is no longer available, which will result in over- or underexposure. The apparent aperture will also change if you add an extender to your lens system, which can again lead to underexposure (unless you catch the change and alter the exposure to suit).

Options:
ISO speed (the selected ISO value will alter should the maximum aperture change because you've changed lenses, zoomed, or added an extender); **Shutter speed** (the selected shutter speed will be shifted, again to avoid underexposure); **Disable** (no adjustment will be made).

» CUSTOM FUNCTIONS 2 📷

› Set shutter speed range

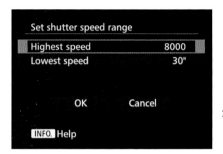

Allows you to narrow the range of available shutter speeds: the **Highest speed** you can set is **15 sec.**, while the **Lowest speed** is **1/4000 sec.** In **P** and **Av** modes the camera will only use shutter speeds within the selected range.

› Set aperture range

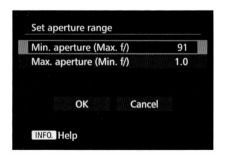

As with shutter speed, you can set the available aperture range using this

function. As lenses have different aperture ranges the choice is slightly more fluid than with shutter speed: the **Min. aperture (Max. f/)** is **f/1.4**; the **Max. aperture (Min. f/)** is **f/64**. In **P** and **Tv** modes the EOS 7D Mark II will only use apertures within the range you've selected.

› Continuous shooting speed

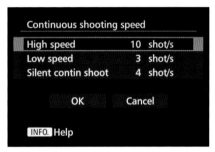

Allows you to customize the maximum shooting speed for **High speed, Low speed**, and **Silent contin shoot**.

Options:
High speed (can be set within the range of **4–10 shot/s**); Low speed (can be set within the range of **1–9 shot/s**); **Silent contin shoot** (can be set within the range of **1–4 shot/s**).

› Focusing Screen

Out of the box, the EOS 7D Mark II is fitted with a 🅛Eh-A focusing screen. If you fit Canon's optional 🅟Eh-S focusing screen you need to register this fact using this menu option. If you don't, you may experience exposure errors.

› Warnings ❶ in viewfinder

The LCD panel built into the viewfinder can be set to display a ❶ symbol to warn you that certain shooting functions have been set. It is up to you whether you take action to rectify the situation or ignore the warning (because it's what you intended).

Options:
When monochrome 🖼M set; When WB is corrected; When one-touch img qual set; When 🖼 is set; When spot meter. is set.

› LV shooting area display

Allows you to set how an image is displayed in Live View when an aspect ratio other than 3:2 is used.

Options:
Masked (the LCD shows only the area that will be captured); **Outlined** (the area to be captured is outlined—this is the better option if you are waiting for a moving subject to enter the image area before you shoot).

› Dial direction during **Tv/Av**

Allows you to set the direction that the exposure is altered in **Tv** and **Av** modes when the dial is turned.

Options:

Normal (default); **Reverse direction** (turning clockwise will set a faster shutter speed **Tv** or smaller aperture **Av**; when using **M** the direction that exposure is set by and is reversed).

› Multi function lock

The **LOCK▶** switch (when moved to the right) can be used to lock the , , , and controls. This can be used to prevent you from accidentally setting the wrong function and you can set **LOCK▶** to lock all one, two, three, or four of the controls (or none at all).

Highlight the control you want to set as lockable and press (SET)—a ✓ will be shown at the left of the control's description. Highlight the control once more and press (SET) to remove locking.

» CUSTOM FUNCTIONS 4 📷

› Custom Controls

Most of the buttons on the EOS 7D Mark II's body are "soft," which means they can be reprogrammed for a different purpose. Doing this allows you to customize your camera to your own personal needs. To set a control, turn ⭕ or press ✛ to highlight the required control. Press (SET) and then select the function you want to assign to that control on the selection page.

› Add cropping information

Allows you to compose using some of the most popular shapes used by film cameras. When an option other than **Off** is selected, crop marks are shown on the Live View image and appended to the image for DPP to crop during postproduction (images are not cropped in-camera).

The aspect ratio has to be set to 3:2 (see page 106) before any option other than **Off** can be selected.

Option	Comments
Off	No cropping information applied.
Aspect ratio 6:6	Square crop.
Aspect ratio 3:4	Analog TV standard and Micro Four Thirds digital cameras.
Aspect ratio 4:5	Common large-format sheet film shape.
Aspect ratio 6:7	Common 120 medium-format film shape.
Aspect ratio 10:12	–
Aspect ratio 5:7	Common large-format sheet film shape.

› Default Erase option

Sets the default option when you press 🗑.

Options:
[Erase] selected (**Erase** will be highlighted first when you press 🗑 making it quicker to delete images); [Cancel] selected (**Cancel** will be highlighted first, making it harder to delete an image accidentally).

› Clear all Custom Func. (C.Fn)

Returns your EOS 7D Mark II to its default settings. This cannot be undone.

CROPPED »
Cropping in postproduction (rather than in-camera) is highly recommended. Adding cropping information to a Raw file allows you to change your mind if you subsequently don't like the crop you originally chose.

3 » MY MENU ★

★ **Set up** allows you to add separate My Menu tabs that can display up to six of your most commonly used menu settings. These My Menu tabs can be given unique (and, for the sake of clarity, relevant) names so that menu options can be found and altered more conveniently.

You can **Delete all my Menu Tabs** and **Delete all items** on the My Menu tabs from the ★ **Set up** screen. You can also force your camera to **Display from My Menu** tab so that when you press MENU you're taken to the My Menu tab first.

If you rarely touch the other menu screens, you can choose to **Display only My Menu tab** so that no other menus are displayed (except the My Menu tabs).

each new tab you add increases in number up to a maximum of five.

2) Select **Configure**, followed by **Select items to register**. Turn ◎ to move up and down the function list.

3) Press (SET) when an option you want to add to My Menu is highlighted. Select **OK** to continue or **Cancel** to return to the **Select items to register** screen without adding the function. When a function has been added to My Menu it will be grayed out and can no longer be selected.

4) Continue to add functions as required (up to six) and then press MENU to return to the My Menu1 settings menu.

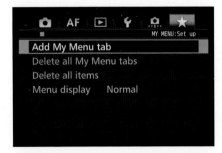

Adding options to My Menu
1) Select **Add My Menu tab** on the ★ **Set up** screen (all other options are initially ghosted out). Select **OK** to continue. The new My Menu tab is called My Menu1—

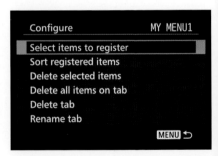

Sorting options registered to My Menu
1) Select **Configure** followed by **Sort registered items**.

2) Select the item that you want to move. Turn ⊙ to move the selected item up and down the list. Press ⓢⓔⓣ.

3) Repeat as necessary and then press MENU when you're done.

Deleting single options registered to My Menu
1) Select **Configure** followed by **Delete selected items**.

2) Turn ⊙ to highlight the option you want to delete, press ⓢⓔⓣ, and then select **OK** to delete the option or **Cancel** to return to the option list.

3) Repeat as necessary. Press MENU when you're done.

Deleting all registered options
1) Select **Configure** followed by **Delete all items on tab**.

2) Select **OK** to continue, or **Cancel** to return to the Configure screen without deleting all the options.

Deleting the My Menu1 tab
1) Select **Configure**, then **Delete tab**.

2) Select **OK** to continue, or **Cancel** to return to the Configure screen without deleting the My Menu1 tab.

Rename tab
1) Select **Configure**, then **Rename tab**.

2) On the text entry page enter a relevant name for your My Menu tab.

3) Press MENU and select **OK** when you've completed the text entry to save the details and return to the main Configure screen. Alternatively, press **INFO.** and select **OK** to return to the main Configure screen without saving a new name for the tab.

> **Note:**
> ★ is not available when the mode dial is set to 🅰.

4 LENSES

The EOS lens system was developed in the 1980s, and there has been a large number of lenses developed for the system since then. If you're prepared to use older, out-of-production lenses, the range of options you could attach to your EOS 7D Mark II is staggering.

If you go to any online retailer and look at the list of lenses available for Canon's DSLRs you will see just how much choice you have. Canon currently produces nearly 70 different types of lens, and if you factor in lenses by third-party manufacturers such as Sigma, Tamron, and Tokina you'll begin to see that there is a lens available to satisfy every photographic requirement you could possibly think of. Some of the lenses border on the esoteric—Canon produces four tilt-and-shift lenses that are very specialized, for example—but there are plenty of other lenses that are more suited to everyday use.

This chapter is an introduction to the range of EF and EF-S compatible lenses. It will cover some of the concepts you'll need to understand in order to make an informed decision about other types of lenses you may want to add to your camera bag.

ZOOM ⌃
The EOS 7D Mark II is often bundled with an 18–135mm zoom. This lens is a good "first" lens, as it arguably covers the most useful focal length range for everyday photography.

HOODED ⌃
A useful accessory for a lens is a lens hood. This stops flare occurring when shooting with the light source just outside the image area.

4 » LENS RANGES

The Canon EOS lens range is split into three main groups. The first—EF-M can be discounted immediately, as it only applies to lenses designed for use with Canon's EOS M compact system.

The second group—EF-S lenses—are lenses designed specifically for Canon's APS-C sensor cameras, such as the EOS 7D Mark II (they physically can't be fitted to Canon's full-frame cameras).

The S in EF-S stands for "short back focus," which refers to the fact that the rear element of an EF-S lens projects far further inside the camera than the rear element of an EF lens. As EF-S lenses are incompatible with full-frame cameras, it makes sense not to buy too many if you're likely to use or own a full-frame camera at some point.

The third group—EF lenses—can be fitted to both APS-C and full-frame DSLRs (and to EF-M cameras via an adaptor). The EF range is subdivided into L series lenses and non-L lenses.

EF lenses make up the bulk of the Canon lens range, with a lineage stretching back to the introduction of the first EOS camera in 1987. There are many deleted EF lenses that are still compatible with the EOS 7D Mark II, and if you're prepared to buy pre-owned lenses this can be an inexpensive way to expand your lens range.

L-series lenses are the very best lenses Canon produces—a fact that's reflected in their price. Many L-series lenses use expensive technologies, such as fluorite glass lens elements and diffraction optics. There are currently no EF-S L-series lenses.

EF-S LENSES ⌃
Canon's EF-S lenses can only be used on DSLRs with an APS-C-sized sensor. This is worth considering if you think you might switch from the EOS 7D Mark II to a full-frame camera at some point in the future.

L-SERIES ⌃
Announced one month after the EOS 7D Mark II, the EF 100-400mm f/4.5-5.6L IS II USM is—at the time of writing—Canon's latest L-series lens.

› ANATOMY OF A LENS

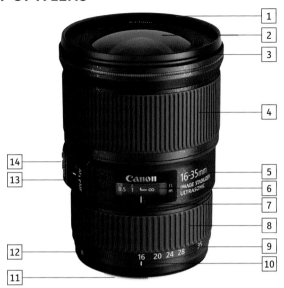

1	Filter thread		**11**	Lens mount
2	Front lens element		**12**	Lens mount index
3	Lens hood mount		**13**	AF/MF switch
4	Focus ring		**14**	Image Stabilizer switch

5 Lens information (model/focal length/features)

6 Focus distance window[1]

7 Focus distance index

8 Zoom ring[2]

9 Focal length range

10 Focal length index mark

[1] Not every Canon lens features a distance scale. EF-S lenses typically don't have a focus distance indicator.

[2] A quirky way that Canon differentiates its zoom lenses is by the positioning of the focus and zoom rings. More expensive zoom lenses (typically L-series) have the focus ring at the front of the lens, with the zoom ring to the rear. Less expensive zooms reverse this order. This unfortunately makes it less intuitive to swap between different lens types.

 » LENS TECHNOLOGY

Canon employs a number of technologies to improve the handling, focusing speed, and optical performance of its lenses. The names of these technologies are often shortened to produce an arcane code that can sometimes make decoding a lens name a slightly head-scratching experience. Here's a list and explanation of some of these technologies, as well as the problems that they're designed to overcome.

Autofocus stop feature (AF-S)

If a lens has an AF-S button you can press it down to temporarily stop autofocus. Autofocus does not resume again until the button is released.

Arc form drive (AFD)

An AFD is a conventional motor that fits within the lens barrel to drive the AF system. This is a system that has largely been superseded by Ultrasonic Motors (USM), but it is still found on some older EF lenses. Compared to USM, AFD motors are relatively slow and noisy.

Diffractive Optics (DO)

DO lenses are smaller and lighter than an equivalent conventional lens, yet they still boast a high optical quality. This is achieved through the use of special (and expensive) glass elements. To date there are only two DO lenses produced by Canon, a 70–300mm zoom and a 400mm prime. Both lenses can be distinguished by a green band around the lens barrel.

Image Stabilizer (IS)

A growing number of Canon lenses are equipped with image stabilization. An IS lens can detect the slight movements that naturally occur when handholding a camera and the optical system in the lens is adjusted to compensate for this.

The most up-to-date iteration of Canon's IS system—Hybrid IS—can compensate for shutter speeds that are 5-stops slower than would normally cause camera shake. It can also compensate for angular velocity and shift.

IS should be turned off when the camera is mounted on a tripod.

Full-time manual focusing (FT-M)

FT-M allows you to override the autofocus at any point without switching AF off permanently. Canon achieves this by using either electronic manual focusing or mechanical manual focusing. Electronic manual focusing detects that the manual focus ring is being moved and uses the focusing motor to move the lens elements. Mechanical manual focusing relies entirely on the manual focus ring being moved to adjust focus.

Internal/Rear focusing (IF/RF)

A lens with internal focusing can focus without the need to extend its physical length. Rear focusing is similar, but in this instance only the lens elements closest to the rear of the camera are moved. A benefit with both systems is that the front lens element does not rotate during focusing. This is useful when using filters that need to be set in a certain orientation.

Stepper Motor (STM)

STM is another type of AF motor, which is designed to make AF smoother (although it is less speedy than USM). STM is most useful if you regularly shoot movies.

Ultrasonic Motor (USM)

This is an autofocus motor built into the lens that allows for fast, quiet, and accurate focusing. Canon uses two types of USM—ring-type and micro. The big advantage of a ring-type USM is that it allows full-time manual focusing in autofocus mode.

MOVIE FRIENDLY ⟨⟨

STM is a relatively recent addition to the range of lens technologies Canon uses. The EF 24-105mm f/3.5-5.6 IS STM is an "everyday" zoom that uses this technology.

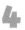

» LENS PROPERTIES

› Focal length

Parallel rays of light converge to a point when they enter a lens that is focused at infinity (∞). This point is known as the focal point. The focal length of a lens is the distance in millimeters from the optical center of the lens to the focal point. In photography the focal point is also referred to as the focal plane. The sensor in the EOS 7D Mark II is placed at the focal plane, which is shown by the ⊖ symbol to the left of the top LCD panel.

The focal length of a lens never alters, so a 50mm lens has the same focal length whatever camera it's mounted to. What does change depending on the camera (or more specifically, its sensor size) is the field of view of a lens. This effect is referred to as the crop factor (see opposite). A lens

can have a fixed focal length—referred to as a "prime" lens—or have a variable focal length, also known as a "zoom" lens (see page 168).

› Field of view

The field of view of a lens is a measurement—in degrees (°)—of the extent of a scene that is projected by the lens onto the film or sensor. The field of view can refer to either the horizontal, vertical, or diagonal coverage. However, if the specification of a lens refers to just one figure it's generally safe to assume that this is the diagonal coverage. There are two factors that affect the field of view of a lens. The first is the focal length of the lens; the second is the size of the sensor used in the camera.

Short focal length lenses are commonly referred to as wide-angle lenses. These

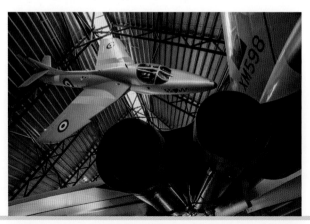

WIDE ANGLE **«**
With their extensive field of view, wide-angle lenses are ideal when you are shooting in tight spaces.

lenses reduce the size of the image projected onto the sensor, so more of the scene is captured. Or, to put it another way, the field of view is wider—hence the name. The most extreme example of a wide-angle lens is a "fisheye" lens, which often has an angular coverage of 180°.

The longer the focal length of a lens, the more the image projected onto the sensor is magnified, reducing the angle of view. Long focal length lenses are known as telephoto lenses, and they appear to bring distant objects closer to you.

› Crop factor

The full-frame sensor is seen as the standard by which all cameras are judged. The reason that not all cameras use full-frame sensors is largely due to cost: it's expensive

to make physically large sensors. Therefore, most DSLR cameras—the EOS 7D Mark II included—use sensors that match the APS-C film size, which is a much smaller format than full-frame. This means that a crop factor must be taken into account when working out the difference in the field of view of a lens between the two sensor sizes.

The EOS 7D Mark II has a crop factor of 1.6x. This means that a lens will appear to have a longer focal length because of the smaller field of view. The practical upshot of this is that wide-angle lenses are less wide, although telephoto lenses will be usefully longer. The important point to remember is that the focal length of the lens hasn't changed; only the field of view. All other aspects of the lens—such as the available depth of field at each aperture—is the same, no matter what sensor size is used.

CROPPED »
This image was shot with a 200mm lens on a full-frame camera. The field of view with the same lens on an EOS 7D Mark II would have been smaller—within the red box at the center. To match the same field of view I would have needed to use a 125mm lens on the EOS 7D Mark II.

A prime lens is one with a fixed focal length, such as 35mm, 50mm, or 100mm. This has the immediate drawback that you can't simply turn a zoom ring to change the look of your composition. Instead, you have to physically move forward or backward and change your camera-to-subject distance.

Oddly enough, this is also one of the appealing things about using a prime lens—because of the effort involved, photography suddenly becomes more rewarding. With practice it also becomes easier to "see" compositions that suit a particular focal length. Indeed, street photographers who use prime lenses exclusively work almost instinctively for this reason.

Another drawback to using primes is that in order to cover a decent focal length range you end up needing multiple lenses, rather than a single zoom lens (particularly a "superzoom" with an extensive focal length range).

However, prime lenses do have some advantages. By their very nature, zooms are mechanically and optically more complicated than primes. Although modern zooms are generally excellent, they still can't match a good prime for ultimate image quality. Prime lenses also tend to have faster maximum apertures than zooms (the fastest zooms in the

Canon range tend to be no faster than f/2.8). A prime with a large maximum aperture is particularly advantageous if you regularly shoot in low-light conditions, or if you like to use minimal depth of field for esthetic reasons.

14MM ⌃
The EF 14mm f/2.8 L is currently the widest prime lens produced by Canon. Fitted to the EOS 7D Mark II it has the equivalent field of view as a 22mm lens on a full-frame camera.

❯❯ EQUIVALENCE

An APS-C camera needs shorter focal length lenses than a full-frame camera to achieve the same field of view. As shorter focal lengths have inherently greater depth of field at a given aperture, this means that you need to use a larger aperture on the APS-C camera than the full-frame camera to achieve the same degree of depth of field: the equivalence is roughly 1-stop. So, if a lens is set to f/4 on a full-frame camera, the APS-C camera lens would need to be set to f/2.8 to match the depth of field.

Settings
> Focal length: 55mm
> Aperture: f/4
> Shutter speed: 25 sec.
> ISO: 100

One of the chief visual characteristics of wide-angle lenses is the way that distance is exaggerated. This means that it is all too easy to produce empty-looking compositions in which the subject appears distant and relatively small in the frame. The key to composing with wide-angle lenses is to get close to your subject so that it appears at a reasonable size in the frame.

Settings
> Focal length: 12mm
> Aperture: f/11
> Shutter speed: 0.4 sec.
> ISO: 100

OTHER LENS OPTIONS

› Teleconverters

There are times when you really need to use a long focal length lens. However, it can be hard to justify the cost of such a lens if it's not used regularly. One solution is to invest in a teleconverter (which is called an "extender" by Canon). A teleconverter is a secondary lens that fits between the body of the camera and the main lens to increase the focal length of the lens by a given factor. Canon currently makes two EOS teleconverters: a 1.4x model that increases the focal length by a factor of 1.4, and a 2x version that doubles focal length.

Unfortunately, teleconverters have drawbacks. Not every lens can be used with a teleconverter, and some lenses will even be damaged if they are used with one. It is therefore important to check whether a lens is compatible before combining it with a teleconverter.

Image quality is also compromised in comparison to a lens used without a teleconverter attached.

Finally, teleconverters reduce the amount of light passing through the lens system, effectively making the lens "slower." In low light this can reduce the effectiveness of the AF system considerably (as well as making the viewfinder darker). A 1.4x teleconverter loses 1-stop of light, a 2x teleconverter loses 2-stops. This means that when a teleconverter is used the central AF points will be more effective than those at the periphery.

EXTENDER EF 1.4X III ⌃ **EXTENDER EF 2X III** ⌃

Teleconverter	Specifications	Dimensions	Weight
Extender EF 1.4x III	7 elements in 3 groups	2.8 x 1.1in. 72 x 27mm	7.9oz 225g
Extender EF 2x III	9 elements in 5 groups	2.8 x 2.1in. 72 x 53mm	11.5oz 325g

Canon produces four "tilt-and-shift" lenses: a 17mm f/4L, 24mm f/3.5L II, 45mm f/2.8, and 90mm f/2.8. These are all manual focus only and have the prefix TS-E.

A tilt-and-shift lens can perform two useful tricks compared to a conventional lens. The first trick is that the front element of the lens can be angled relative to the camera ("tilt"). The second is the ability to move the front lens element up or down, left or right ("shift").

Tilting the front element of a lens allows you to control the plane of focus in an image. This technique can be used to throw large areas of an image out of focus or to increase sharpness throughout an image without resorting to the use of small apertures. This latter trait is useful for avoiding diffraction when you want to achieve front-to-back sharpness.

Shifting the front element of a lens is useful to avoid "converging verticals." This is an optical effect caused when a camera is tilted backward (or forward) to fit a vertical subject into a composition. This results in the vertical lines of a subject no longer appearing parallel to each other. Shifting a lens allows you to keep the camera parallel to the subject and adjust your composition to include the required elements of your subject.

Note:
Canon is not the only manufacturer of tilt-and-shift lenses for the EOS lens mount. Third-party lens manufacturer Samyang produces a highly regarded 24mm tilt and shift lens.

CANON TS-E 17MM ⌃
On the EOS 7D Mark II, the angle of view of the 17mm TS-E is equivalent to a 27mm lens on a full-frame camera. This makes it a useful wide-angle lens for architectural interiors. However, it is less useful as a "landscape" lens, as the bulbous front element makes it very difficult to fit filters.

› Third-party lenses

There's no completely compelling reason to use only Canon lenses—buying a lens produced by a third-party manufacturer has a lot to recommend it. The main reason is price, as third-party lenses are typically cheaper than an equivalent Canon lens, although there are also some lenses made by third parties that have no Canon equivalent.

There are three main manufacturers of lenses for the EOS system: Sigma, Tamron, and Tokina. Sigma and Tamron produce extensive ranges that include both prime lenses and zooms. The Tokina range is smaller and is composed mainly of zoom lenses (the exception being a 100mm macro lens). A more niche range of prime, manual focus lenses is produced by Zeiss: the limitation of only having manual focus is offset by superb optical quality.

There are a few downsides to using third-party lenses. For a start, **Lens aberration correction** doesn't support third-party lenses (and likely never will). Fortunately, postproduction software such as Adobe Lightroom can be used to correct a similar range of lens flaws.

Another potential problem is the long-term compatibility of a third-party lens with Canon cameras. Canon doesn't license its AF technology to other manufacturers, so if it was to one day subtly change the way its AF technology

worked, then third-party lenses could become incompatible. It's a very small risk, but it is another factor to consider.

FISHEYE ⌃
Third-party lens manufactures often produce interesting lenses of a type ignored by Canon. Sigma's 4.5mm circular fisheye lens has no Canon equivalent.

> **Note:**
> Sigma, Tamron, and Tokina all produce lenses that are designed purely for use with APS-C cameras such as the EOS 7D Mark II. Sigma uses the code DC to signify this type of lens; Tamron uses the code Di II; and Tokina uses DX for its APS-C-only lenses.

4 » DIFFRACTION

Lenses are typically at their best optically when they are 2 or 3 stops from their maximum aperture. Once past this "sweet spot," images can start to look softer, with a reduction in fine detail.

This is due to an effect known as "diffraction." When light enters a lens it is randomly scattered (diffracted) as it strikes the edges of the aperture blades. Diffraction is at its worst when using a lens' minimum aperture.

For this reason it's a good idea to avoid using the smallest apertures on a lens if possible, which means you need to think carefully about depth of field. Fortunately, there's a technique that can be used to optimize the depth of field: the technique requires the lens to be focused at a point known as the "hyperfocal distance."

By setting the lens to the hyperfocal distance, the image will be sharp from half that distance to infinity. By focusing this way and using the largest aperture that will comfortably cover the required depth of field, you reduce the risk of diffraction.

On the page opposite is a set of hyperfocal distance charts covering the focal length range of the 18–135mm kit lens commonly sold with the EOS 7D Mark II. The charts can also be used for any lens with a focal length that falls between 18mm and 135mm.

To use the charts, first set the lens to the required focal length, then set the focus distance to the hyperfocal distance (HD). Note that some lenses don't have distance scales, so you may need to guess.

Finally, set the required aperture. It pays to be slightly conservative here, so if in doubt, set the aperture slightly smaller than that specified in the table. Now, depth of field will stretch from the Near point indicated in the chart to Infinity (∞). Note that all distances are in meters.

LONG EXPOSURES «
Deliberately shooting long exposures often means using small apertures. However, to avoid diffraction it is often better to use ND filters to artificially simulate low light levels.

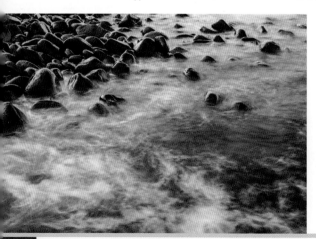

18mm: Hyperfocal distance

f/2.8		f/4		f/5.6		f/8		f/11		f/16	
Near	HD	Near	HD	Near	HD	Near	HD	Near	HD	Near	HD
3.05	6.09	2.13	4.26	1.52	3.05	1.07	2.13	0.78	1.55	0.53	1.07

24mm: Hyperfocal distance

f/2.8		f/4		f/5.6		f/8		f/11		f/16	
Near	HD	Near	HD	Near	HD	Near	HD	Near	HD	Near	HD
5.41	10.83	3.79	7.58	2.71	5.41	1.89	3.79	1.38	2.76	0.95	1.89

35mm: Hyperfocal distance

f/2.8		f/4		f/5.6		f/8		f/11		f/16	
Near	HD	Near	HD	Near	HD	Near	HD	Near	HD	Near	HD
11.5	23	8.06	16.1	5.76	11.5	4	8	2.9	5.9	4	2

50mm: Hyperfocal distance

f/2.8		f/4		f/5.6		f/8		f/11		f/16	
Near	HD	Near	HD	Near	HD	Near	HD	Near	HD	Near	HD
23.5	47	16.4	32.8	11.7	23.5	8.2	16.4	6	12	4.1	8.2

85mm: Hyperfocal distance

f/2.8		f/4		f/5.6		f/8		f/11		f/16	
Near	HD	Near	HD	Near	HD	Near	HD	Near	HD	Near	HD
68	135	48	95	34	68	24	48	17	35	12	24

135mm: Hyperfocal distance

f/2.8		f/4		f/5.6		f/8		f/11		f/16	
Near	HD	Near	HD	Near	HD	Near	HD	Near	HD	Near	HD
171	340	120	240	85	171	60	120	43	87	30	60

Certain lens types are associated with certain types of photography. Opinion would have you believe that you wouldn't use a wide-angle lens for a portrait or use a telephoto for a landscape. In fact, wide-angle lenses can be used very successfully to shoot environmental portraits that show your subject in the context of their surroundings. Alternatively, telephotos can be used to fill the frame with a landscape subject and exclude unwanted detail, as in this shot.

Settings
> Focal length: 200mm
> Aperture: f/11
> Shutter speed: 1/25 sec.
> ISO: 100

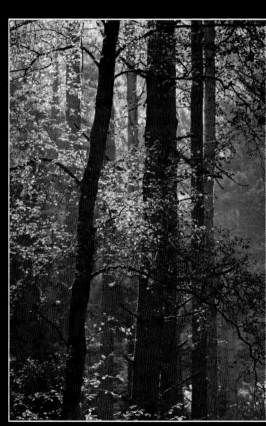

CANON EF/EF-S LENSES

Lens	35mm equiv.	Filter size	L x W (mm)	Weight (grams)
EF 8-15mm f/4L USM	12.8-24mm	67mm	79 x 83	540
EF-S 10-18mm f/4.5-5.6 IS STM	16-28mm	67mm	75 x 72	240
EF-S 10-22mm f/3.5-4.5 USM	16-35mm	77mm	83 x 90	385
EF 14mm f/2.8L II USM	22mm	rear	80 x 94	645
EF 15mm f/2.8 Fisheye	–	rear	73 x 62	330
EF-S 15-85mm f/3.5-5.6 IS USM	22-136mm	72mm	82 x 88	575
EF 16-35mm f/2.8L II USM	25-56mm	82mm	88 x 112	635
EF 16-35mm f/4L IS USM	25-56mm	77mm	83 x 113	615
TS-E 17mm f/4L	27mm	n/a	89 x 107	820
EF 17-40mm f/4L USM	27-64mm	77mm	83 x 97	500
EF-S 17-55 f/2.8 IS USM	27-88mm	77mm	83 x 111	645
EF-S 17-85mm f/4-5.6 IS USM	27-136mm	67mm	78 x 92	475
EF-S 18-55mm f/3.5-5.6 III	28-88mm	58mm	68 x 70	195
EF-S 18-55mm f/3.5-5.6 IS STM	28-88mm	58mm	69 x 75	205
EF-S 18-55mm f/3.5-5.6 IS II	28-88mm	58mm	68 x 70	200
EF-S 18-135mm f/3.5-5.6 IS	28-216mm	67mm	75 x 101	455
EF-S 18-135mm f/3.5-5.6 STM	28-216mm	67mm	77 x 96	480
EF-S 18-200mm f/3.5-5.6 IS	28-320mm	72mm	79 x 162	595
EF 20mm f/2.8 USM	32mm	72mm	77 x 71	405
EF 24mm f/1.4L II USM	38mm	77mm	93 x 87	650
EF 24mm f/2.8 IS USM	38mm	58mm	68 x 56	280
EF-S 24mm f/2.8 STM	38mm	52mm	68 x 23	125
TS-E 24mm f/3.5L II	38mm	82mm	78 x 87	570
EF 24-70mm f/2.8L USM	38-112mm	77mm	83 x 123	950
EF 24-70mm f/2.8L II USM	38-112mm	82mm	88 x 113	805
EF 24-70mm f/4L USM	38-112mm	77mm	83 x 93	600
EF 24-105mm f/3.5-5.6 IS STM	38-168mm	77mm	83 x 104	525
EF 24-85mm f/3.5-4.5 USM	38-136mm	77mm	73 x 69.5	380
EF 24-105mm f/4L IS USM	38-168mm	77mm	83 x 107	670

Lens	35mm equiv.	Filter size	L x W (mm)	Weight (grams)
EF 28mm f/1.8 USM	45mm	58mm	73 x 56	310
EF 28mm f/2.8	45mm	52mm	67 x 42	185
EF 28mm f/2.8 IS USM	45mm	58mm	68 x 51	280
EF 28-80mm f/3.5-5.6 II	45-128mm	67mm	67 x 71	220
EF 28-90mm f/4-5.6 II USM	45-144mm	58mm	67 x 71	190
EF 28-90mm f/4-5.6 III	45-144mm	58mm	67 x 71	190
EF 28-105mm f/3.5-4.5 II USM	45-168mm	58mm	72 x 75	375
EF 28-105mm f/4.0-5.6 USM	45-168mm	58mm	67 x 68	210
EF 28-135mm f/3.5-5.6 IS USM	45-216mm	72mm	78 x 97	540
EF 28-200mm f/3.5-5.6 USM	45-320mm	72mm	78 x 90	500
EF 28-300mm f/3.5-5.6L IS USM	45-480mm	77mm	92 x 184	1670
EF 35mm f/1.4L USM	56mm	72mm	79 x 86	580
EF 35mm f/2	56mm	52mm	67 x 42	210
EF 40mm f/2.8 STM	64mm	52mm	68 x 27	130
TS-E 45mm f/2.8	72mm	72mm	81 x 90.1	645
EF 50mm f/1.2L USM	80mm	72mm	86 x 65	580
EF 50mm f/1.4 USM	80mm	58mm	74 x 50	290
EF 50mm f/1.8 II	80mm	52mm	68 x 41	130
EF 50mm f/2.5 Compact Macro	80mm	52mm	67 x 63	280
EF 55-200mm f/4.5-5.6 II USM	88-320mm	77mm	92 x 184	1670
EF-S 55-250mm f/4-5.6 IS	88-400mm	58mm	71 x 109	391
EF-S 60mm f/2.8 Macro USM	96mm	52mm	73 x 70	335
MP-E 65mm f/2.8 1-5x Macro	104mm	58mm	81 x 98	730
EF 70-200mm f/2.8L IS II USM*	112-320mm	77mm	89 x 199	1490
EF 70-200mm f/2.8L USM*	112-320mm	77mm	76 x 194	1310
EF 70-200mm f/4L IS USM*	112-320mm	67mm	76 x 172	760
EF 70-200mm f/4L USM*	112-320mm	67mm	76 x 172	705
EF 70-300mm f/4.5-5.6 DO IS USM	112-480mm	58mm	82 x 99	720
EF 70-300mm f/4-5.6 IS USM	112-480mm	58mm	76 x 143	630

* Indicates that a lens is compatible with Canon's teleconverters. + Drop-in filter size

Lens	35mm equiv.	Filter size	L x W (mm)	Weight (grams)
EF 70–300mm f/4–5.6L IS USM	112–480mm	67mm	89 x 143	1050
EF 75–300mm f/4–5.6 III	120–480mm	58mm	71 x 122	480
EF 75–300mm f/4–5.6 III USM	120–480mm	58mm	71 x 122	480
EF 80–200mm f/4.5–5.6 II	128–320mm	52mm	69 x 78.5	250
EF 85mm f/1.2L II USM	136mm	72mm	91 x 84	1025
EF 85mm f/1.8 USM	136mm	72mm	91 x 84	1025
TS-E 90mm f/2.8	144mm	58mm	74 x 88	565
EF 100mm f/2 USM	160mm	58mm	75 x 73	460
EF 100mm f/2.8 Macro USM	160mm	58mm	79 x 119	600
EF 100mm f/2.8L Macro IS USM	160mm	67mm	78 x 123	625
EF 100–300mm f/4.5–5.6 USM	160–480mm	58mm	73 x 121	540
EF 100–400mm f/4.5–5.6L IS USM*	160–640mm	77mm	92 x 189	1380
EF 100–400mm f/4.5–5.6L IS II USM*	160–640mm	77mm	94 x 193	1570
EF 135mm f/2.8 soft focus	216mm	52mm	69 x 98	390
EF 135mm f/2L USM*	216mm	72mm	82 x 112	750
EF 180mm f/3.5L Macro USM*	288mm	72mm	82 x 186	1090
EF 200mm f/2L IS USM*	320mm	52mm+	128 x 208	2520
EF 200mm f/2.8L II USM*	320mm	72mm	83 x 136	765
EF 200–400mm f/4L IS*	320–640mm	58mm	73 x 122	540
EF 300mm f/2.8L IS II USM*	480mm	52mm+	128 x 248	2400
EF 300mm f/4L IS USM*	480mm	77mm	90 x 221	1190
EF 400mm f/2.8L IS II USM*	640mm	52mm+	163 x 343	3850
EF 400mm f/4 DO IS USM*	640mm	52mm+	128 x 233	1940
EF 400mm f/4 DO IS II USM*	640mm	52mm+	128 x 233	1200
EF 400mm f/5.6 L USM*	640mm	77mm	90 x 256.5	1250
EF 500mm f/4L IS USM*	800mm	52mm+	146 x 383	3190
EF 500mm f/4L IS II USM*	800mm	52mm+	168 x 449	3920
EF 600mm f/4L IS USM*	960mm	52mm+	168 x 456	5360
EF 600mm f/4L IS II USM*	960mm	52mm+	168 x 448	3920
EF 800mm f/5.6L IS USM*	1280mm	52mm+	163 x 461	4500

Low light means one of two things: you either accept that obtaining the correct exposure will require a slow shutter speed, large aperture, and/or high ISO, or you add your own light to the scene.

In photography, the most common way of adding light is to use flash. However, the EOS 7D Mark II's built-in flash has a few limitations—unless you're aware of these, you could be disappointed by the results.

The first (and most frustrating) of these limitations is power. With a guide number of 36.1ft/11m at ISO 100, the built-in flash is not the most powerful light source ever devised. This lack of power means it has a small effective range, so only subjects close to the camera may be illuminated correctly.

The second limitation is that the built-in flash is a frontal light. This type of lighting isn't appealing, as it flattens subjects and makes them appear less three-dimensional.

Ultimately, if you want to progress with flash, you'll need to invest in an external flash (or Speedlite). That's when the fun can really begin. This chapter is an introduction to the world of flash with your EOS 7D Mark II, and a guide to show you how taking a few simple steps can improve your flash photography.

> **Note:**
> Canon uses the word Speedlite as a synonym for an external flash, which is the convention used in this chapter.

WIRELESS ⌃
The EOS 7D Mark II's built-in flash can be used to trigger a compatible off-camera flash wirelessly.

OFF-CAMERA »
Taking a Speedlite off-camera allows you to illuminate your subject more creatively.

5 » FLASH BASICS

› Anatomy of a flash

Whether it's built into a camera or a separate Speedlite, the basic components of a flash are a power source, a capacitor, and an airtight chamber filled with xenon gas. The power source (typically a battery) charges up the capacitor so that the flash is ready for use. The length of time it takes the capacitor to charge up is known as the recycling time (as the battery becomes depleted the recycling time will lengthen).

When the flash is fired, the capacitor is discharged, pulsing an electrical charge into the xenon gas. This charge causes the molecules of gas to release energy in the form of light. If the flash is fired at full power the capacitor's entire charge is used and so the flash will need to recharge fully before it can be fired again. However, if the flash is fired at half power, only half the capacitor's charge is used and so the flash will be able to fire twice before needing to recharge. At quarter power the flash will be able to fire four times before needing to recharge, and so on.

The power output set for the flash controls the amount of light released, but it's important to understand that the brightness of the flash is constant. What altering the power changes is the length of time that the flash emits light. At full power, the energy "tap" is turned on until the capacitor

is exhausted, resulting in a relatively long flash of light (lasting approximately 1/800 sec.). At half power the energy "tap" is turned off in half that time (approximately 1/1600 sec.), which results in a halving of the light emitted. At a quarter power the flash duration is halved again and the amount of light emitted it reduced still further. Every halving of power results in a shortening of the duration of light emission, which effectively means the flash emits less light.

> **Note:**
> Using a lower power setting makes it easier to freeze movement with flash. The downside is that you need to be closer to your subject to effectively illuminate it.

COMMONALITY «
All flashes work on the same principle, although you will usually have more control over how light is output—its power and direction, for example—if you use a higher-end Speedlite model.

› Flash metering

There are two basic methods for controlling the light output of a flash. You can either let the EOS 7D Mark II use a proprietary exposure system known as E-TTL II to automatically determine the correct flash exposure, or you can set the flash to manual and adjust the flash exposure yourself (as described on the following page).

Generally, E-TTL II is an accurate system, but it's not entirely foolproof and the reflectivity of your subject(s) can affect the flash exposure. Although setting flash exposure manually is more complicated it makes the results more consistent and therefore predictable.

When flash is set to manual, there are two main ways to control its effective distance (the maximum distance that the flash can effectively illuminate a subject). The first control is flash exposure compensation (or adjusting the power output of the Speedlite if this option is available); the second exposure control is the aperture set on the camera.

The smaller the aperture used, the shorter the effective distance of the flash becomes. If your subject is further from the camera than the effective flash distance for the selected aperture it will be underexposed. You would therefore

need to use a wider aperture. Alternatively, if your subject is overexposed this can be remedied by using a smaller aperture.

Notes:
The shutter speed has no influence on the flash exposure. However, the shutter speed you use will affect the exposure of any area of a scene not lit by light from the flash. This is useful for slow sync exposures, as described later in this chapter.

Increasing the ISO also increases the effective distance of flash.

RING LIGHTING ⨠
Canon's Macro Ring Lite MR141-EX II is a specialized Speedlite that fits onto the lens of your camera for lighting close-up subjects. Yet despite its unconventional looks, it still functions in exactly the same way as any other Canon Speedlite.

5 » GUIDE NUMBER (GN)

The power of a flash (the maximum amount of light it can produce) is indicated by its "guide number" or GN. The GN determines the effective range of the flash in either feet or meters. If you increase the ISO on your camera, the GN also increases (by a factor of 1.4 every time the ISO is doubled), so to avoid confusion, camera and flash manufacturers use ISO 100 as the standard reference when quoting a GN.

If you know the GN of a flash, you can use this to determine either the required aperture value for a subject at a given distance, or the effective range of the flash at a specified aperture. The formula to calculate both is respectively:

Aperture=GN/distance
Distance=GN/aperture

The built-in flash on the EOS 7D Mark II has a GN of 36.1ft/11m at ISO 100. You can use the grid below to quickly work out the effective distance of the built-in flash for a typical range of apertures and distances. There are also many apps available for smartphones and tablet computers that help make flash exposure calculations easier in the field.

ISO	Aperture					
	f/2.8	f/4	f/5.6	f/8	f/11	f/16
100	12' 9" 3.9m	8' 10" 2.7m	6' 2" 1.9m	4' 7" 1.4m	3' 3" 1m	2' 4" 0.7m
200	18' 4" 5.6m	12' 9" 3.9m	8' 10" 2.7m	6' 2" 1.9m	4' 7" 1.4m	3' 6" 1m
400	25' 11" 7.9m	18' 4" 5.6m	12' 9" 3.9m	8' 10" 2.7m	6' 2" 1.9m	4' 7" 1.4m
800	36' 5" 11.1m	25' 11" 7.9m	18' 4" 5.6m	12' 9" 3.9m	8' 10" 2.7m	6' 2" 1.9m
1600	51' 6" 15.7m	36' 5" 11.1m	25' 11" 7.9m	18' 4" 5.6m	12' 9" 3.9m	8' 10" 2.7m
3200	72' 10" 22.2m	51' 6" 15.7m	36' 5" 11.1m	25' 11" 7.9m	18' 4" 5.6m	12' 9" 3.9m
6400	103' 31.4m	72' 10" 22.2m	51' 6" 15.7m	36' 5" 11.1m	25' 11" 7.9m	18' 4" 5.6m
12,800	146' 44.4m	103' 31.4m	72' 10" 22.2m	51' 6" 15.7m	36' 5" 11.1m	25' 11" 7.9m

⏺ BUILT-IN FLASH

The EOS 7D Mark II's guide number of 11m/36.1ft at ISO 100 isn't spectacular, particularly when compared to a middle-of-the-road Speedlite, such as the 320EX. Certainly, if you want to use the built-in flash to illuminate a large room you'll be disappointed. However, any flash is better than none when you need a little extra illumination. The most effective use for the built-in flash is as a fill-in light when shooting backlit subjects close to the camera.

When the mode dial is set to [A⁺] you have limited control over the built-in flash. Via the [Q] screen you can set the flash to rise automatically if necessary ⚡ᴬ, switch it on all the time ⚡, or disable it entirely ⚡. You can also set red-eye reduction using the 🔲 2 screen. However, to have complete control over the built-in flash (including such options as modifying the power of the flash and what exposure mode is used) you will need to set your EOS 7D Mark II to one of the other shooting modes.

Raising and using the flash
1) Press the ⚡ button just above the lens-release button.

2) Press down halfway on the shutter-release button to focus as normal. If the flash is ready for use ⚡ will be displayed at the bottom left corner of the viewfinder.

3) Press down fully on the shutter-release button to take the photo.

4) The flash needs to charge up after use so there may be a short delay before the next exposure can be made. During this time ⚡ buSY will be displayed in the viewfinder and BUSY ⚡ will be shown on the rear LCD screen.

Warning!

If you have a lens hood or filter holder attached to your lens, remove it before you use the built-in flash.

Don't try to raise the built-in flash if you have an external flash fitted to the camera's hotshoe.

FLASH »
The built-in flash can be used to trigger a compatible Speedlite wirelessly, as outlined later in this chapter.

› Red-eye reduction

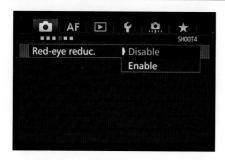

Using the built-in flash or a small Speedlite fitted to the hotshoe to illuminate a portrait subject looking directly at the camera can result in an effect known as "red-eye." Red-eye is caused by the light from the flash bouncing off the back of the subject's eyes and reflecting toward the camera, picking up the color of the blood vessels inside the eyes as it does so. The problem is made worse by the fact that flash is most often used in low-light conditions when the pupils in eyes are at their widest.

Red-eye reduction activates the camera's red-eye reduction lamp before the final exposure is made. This causes the pupils of your subject's eyes to contract, reducing the risk of red-eye.

Enabling Red-eye reduction

1) Select **Red-eye reduc.** from the ◻ 4 menu (◻ 2 when using Ⓐ⁺).

2) Select **Enable** and then press the shutter-release button down lightly to return to shooting mode.

3) Press the shutter-release button down halfway to focus your camera. The orange red-eye reduction lamp should now light. Looking through the viewfinder, the usual exposure scale at the bottom of the viewfinder will be replaced by a long bar. Keep your finger on the shutter-release button and then press down to take the shot when the bar disappears.

> ***Notes:***
> The risk of red-eye is reduced the further the flash is from the camera lens. This is impossible with the built-in flash, but is effective if you use an extension cable or wireless control with an external flash.
>
> Red-eye reduction is set to **Disable** by default.
>
> The red-eye reduction lamp isn't very subtle. If you want to maintain an element of surprise or avoid disturbing your subject, switch **Red-eye reduc.** to **Disable**.

Flash exposure can be locked in a similar way that a regular exposure can be locked using AE lock. The big difference is that the EOS 7D Mark II must first fire a test or pre-flash to determine the correct exposure before it's locked. This makes FE lock less than subtle, so it's not recommended if you are shooting a subject candidly.

FE lock can be applied to both the built-in flash and an attached Speedlite. FE lock is particularly useful when your subject is off-center and an overly light or dark background may make normal flash exposure unreliable.

Setting FE lock

1) Raise the built-in flash, or attach and switch on your Speedlite.

2) Press the shutter-release button down halfway to focus. Check that ⚡ is displayed in the viewfinder. Aim the camera so your subject is at the center of the viewfinder.

3) Press the M-Fn button. The flash will fire and the exposure details will be recorded, with the result shown on the exposure level indicator at the right of the viewfinder. FEL will be displayed briefly in the viewfinder and ⚡* will replace ⚡. Each time you press M-Fn the flash will fire and new exposure details will be recorded.

4) Recompose your shot and press the shutter-release button down fully to make the final exposure.

5) FE lock is cancelled after a few seconds unless you keep the shutter-release button pressed down halfway.

> **Notes:**
> If ⚡ blinks in the viewfinder your subject distance exceeds the effective flash distance. To remedy this move closer to your subject, use a larger aperture, and/or increase the ISO.
>
> You cannot use FE lock when using Live View.

» FLASH CONTROL MENU

The Flash control menu, found at the bottom of the 📷 1 menu, offers a range of options that enable you to set the parameters of the built-in flash and compatible Speedlites (when fitted and switched on).

› Flash firing

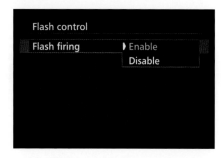

Set to **Enable**, the built-in flash or an attached Speedlite will fire when a shot is taken (assuming either flash has been activated first). Set to **Disable**, neither will fire, but the AF assist beam on the Speedlite will still activate (if it has one). The AF assist beam is most useful when there is not enough ambient light for effective autofocusing.

› E-TTL II metering

E-TTL stands for "evaluative through-the-lens metering," with the "II" after the name indicating this is the second iteration of the Canon technology. E-TTL II puts flash exposure entirely in the hands of the camera. This is generally very accurate, and it takes the headache out of calculating flash exposure when a Speedlite is used off-camera and when filters are used.

E-TTL II works by firing the flash twice. The first burst of light is a "pre-flash," which is assessed by the camera to determine the exposure that's needed. The second burst is used to make the exposure, with the power of the second burst modified (if necessary) so the subject is correctly exposed. This happens so quickly that you won't even be aware there were two bursts of flash.

If used with a compatible lens, E-TTL II also uses the focus distance as a factor in determining accurate exposure. The grid opposite lists compatible lenses.

The EOS 7D Mark II offers two methods for determining exposure using E-TTL II metering. The default is **Evaluative**, which is the recommended option. However, if you're using a lens that doesn't supply focus distance information, **Average** may be marginally preferable—experimentation will determine which is most suitable for your purposes.

Fully E-TTL II compatible lenses that supply distance information

EF-S 10–22mm f/3.5–4.5 USM	EF 50mm f/1.2L USM
EF 14mm f/2.8L USM	MP-E 65mm f/2.8 1–5x Macro
EF 16–35mm f/2.8L USM	EF 70–200mm f/2.8L IS USM
EF 16–35mm f/2.8L II USM	EF 70–200mm f/2.8L USM
EF 17–35mm f/2.8L USM	EF 70–200mm f/4L USM
EF 17–40mm f/4L USM	EF 70–210mm f/3.5–4.5 USM
EF-S 17–55mm f/2.8 IS USM	EF 70–300mm f/4.5–5.6 DO IS USM
EF-S 18–55mm f/3.5–5.6 USM	EF 70–300 f/4–5.6 IS USM
EF-S 18–55mm f/3.5–5.6	EF 85mm f/1.2L II
EF-S 18–55mm f/3.5–5.6 II	EF 85mm f/1.8 USM
EF-S 18–55mm f/3.5–5.6 IS	EF 90–300mm f/4.5–5.6 USM
EF 20mm f/2.8 USM	EF 90–300mm f/4.5–5.6
EF 20–35mm f/3.5–4.5 USM	EF 100mm f/2 USM
EF 24mm f/1.4L USM	EF 100mm f/2.8 Macro USM
EF 24–70mm f/2.8L USM	EF 100mm f/2.8L Macro USM
EF 24–70mm f/2.8L II USM	EF 100–300mm f/4.5–5.6 USM
EF 24–85mm f/3.5–4.5 USM	EF 100–400mm f/4.5–5.6L IS USM
EF 24–105mm f/4L IS USM	EF 135mm f/2L USM
EF 28mm f/1.8 USM	EF 180mm f/3.5L Macro USM
EF 28–70mm f/2.8L USM	EF 200mm f/2L IS USM
EF 28–80mm f/3.5–5.6 USM	EF 200mm f/2.8L USM
EF 28–105mm f/3.5–4.5 USM	EF 200mm f/2.8L II USM
EF 28–105mm f/3.5–4.5 II USM	EF 300mm f/2.8L IS USM
EF 28–105mm f/4–5.6 USM	EF 300mm f/4L USM
EF 28–105mm f/4–5.6	EF 300mm f/4L IS USM
EF 28–135mm f/3.5–5.6 IS USM	EF 400mm f/2.8L IS USM
EF 28–200mm f/3.5–5.6 USM	EF 400mm f/4 DO IS USM
EF 28–200mm f/3.5–5.6	EF 400mm f/5.6L USM
EF 28–300mm f/3.5–5.6	EF 500mm f/4L IS USM
EF 28–300mm f/3.5–5.6L IS USM	EF 600mm f/4L IS USM
EF 35mm f/1.4L USM	EF 800mm f/5.6L IS USM
EF 35–135mm f/4–5.6 USM	EF 1200mm f/5.6L USM

```
Flash sync. speed in Av mode

Auto                          AUTO
1/250-1/60sec. auto          1/250
                             -1/60 A
1/250 sec. (fixed)           1/250

INFO. Help
```

The fastest shutter speed that can be used when shooting with flash is 1/250 sec.—a speed known as the X-sync speed (or simply the "sync speed"). However, that doesn't mean you can't use slower shutter speeds.

Slow sync flash is the technique of using shutter speeds longer than the X-sync speed. This allows you to accurately expose the areas of a scene that aren't affected by the flash (areas lit only by ambient light). Slow sync flash photography is effective at dusk when the ambient light level is low (but still sufficient to make an exposure) and you want to use flash to illuminate your subject.

However, the lower the ambient light level, the longer the shutter speed will need to be. This increases the risk of camera shake and necessitates the use of a tripod. **Flash sync. speed in AV mode** allows you to change how the EOS 7D Mark II sets the shutter speed in Av mode when using slow sync flash.

Setting Flash sync. speed in Av mode
1) Select **Flash sync. speed in Av mode**.

2) Select the option you require (see below). Press down lightly on the shutter-release button to return to shooting mode and set the mode dial to **Av**.

Option	Result
Auto	The EOS 7D Mark II will use a shutter speed of between 30 sec. and 1/250 sec. to achieve correct exposure for non-flash-lit areas. Hi-speed sync with a compatible Speedlite is still possible.
1: 1/250–1/60 sec. auto	To minimize the risk of camera shake, the camera will use a shutter speed between 1/60 sec. and 1/250 sec. This may result in underexposed areas that are not illuminated by flash.
2: 1/250 sec. (fixed)	Only the sync speed of 1/250 sec. is available. Non-flash-lit areas may be underexposed, but the risk of camera shake will be minimized.

» HOTSPOTS

Shooting highly reflective subjects with a naked flash can cause bright, distracting hotspots. This can be avoided by positioning a large diffusion screen between the flash and the subject to soften the light from the flash. This image was shot in a darkened room, with a diffused flash as the only source of illumination.

Settings
> Focal length: 40mm
> Aperture: f/8
> Shutter speed: 60 sec.
> ISO: 200

» BUILT-IN FLASH SETTINGS

Select **Built-in flash** on the **Flash control** menu and you will be taken to another screen of options that allows you to further refine the use of the built-in flash.

› Flash mode

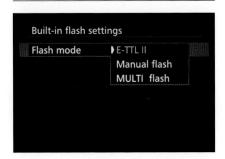

You can either set your Speedlite to use **E-TTL II** metering (the default) or switch to **Manual flash** exposure. Once set to **Manual flash** you must determine the flash exposure yourself, taking into account the guide number of the flash, the power output of the flash, and the ISO and aperture you've set on your camera.

MULTI flash sets your built-in flash to fire a set number of times during a long exposure. This allows you to illuminate a moving subject so that it appears in several different places in the final image (creating a stroboscopic effect). If you select **MULTI flash** you also have to set ◢ **flash output** between **1/32** and **1/128** power. At **1/32**

the flash strength will be far greater than at **1/128**; the downside is that the flash will take a fraction longer to recycle and may not be able to complete the required number of flashes during the exposure.

The values selected for **Frequency** and **Flash count** determine the shutter speed required. The calculation to use is: **Flash count/Frequency**=shutter speed.

As an example, if you set **Flash count** to **10** and **Frequency** to **5Hz** (or "flashes per second"), the shutter speed required is 2 sec. (10/5=2). Note that Canon recommends not using **MULTI flash** more than 10 times in succession to prevent the flash from overheating.

› Shutter sync.

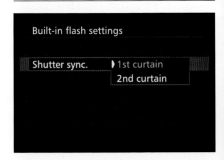

The shutter in your EOS 7D Mark II consists of two light-tight metal curtains, one in front of the other. When the shutter-release button is pressed down, the first

curtain begins to rise, exposing the sensor to light. After a set period of time, the second curtain follows, stopping the sensor's exposure to light as it does so. The period of time between the first and second curtains rising is the length of the selected shutter speed.

If you set **Shutter sync.** to **1st curtain**, the flash is fired when the first curtain starts to rise. The movement of your subject across the frame during the exposure will be frozen by the light from the flash at the start of the exposure. If the shutter speed is sufficiently long, the ambient light will light the rest of the exposure and any subsequent movement will be recorded as a blur that appears in front of the subject.

If you set **Shutter sync.** to **2nd curtain**, the flash is fired when the second curtain starts to rise. This means the movement of your subject is frozen by the flash at the end of the exposure, resulting in any movement being recorded as a blur behind the subject. Of the two settings, **2nd curtain** usually looks far more natural.

› ◢ exp. comp.

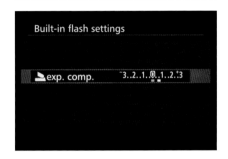

Your EOS 7D Mark II uses E-TTL II metering by default to correctly calculate the exposure for the built-in flash and any fitted Speedlite. However, it's not infallible and sometimes exposure with flash can be inaccurate. As with standard exposures you can apply exposure compensation to your flash images using ◢ **exp. comp.** The maximum flash exposure compensation is ±3 stops. Flash exposure can be adjusted one of three ways on your EOS 7D Mark II.

Setting flash exposure compensation

1) Select **Flash control** on the ◻ 1 menu, followed by **Built-in flash settings**.

2) Select ◢ **exp. comp.** and press ◀ to decrease the power of the flash or press ▶ to increase it. Press ⑤ᴱᵀ to apply the changes and return to the **Built-in flash settings** screen.

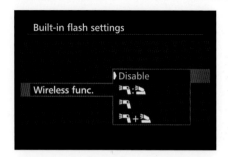

The EOS 7D Mark II's built-in flash isn't just for illumination. It can also be used to trigger compatible off-camera Speedlites, giving you greater control over the direction of light relative to your subject. A flash that's used as a trigger is referred to as a master flash; the triggered Speedlites are referred to as slaves.

The built-in flash uses infrared light to trigger slave Speedlites (the technology referred to as "optical wireless"). The infrared sensor on a compatible Speedlite is found on the front panel below the flash head. If this sensor cannot "see" the built-in flash, the Speedlite may not trigger successfully. However, a simple way of maintaining line of sight is to point the body of the Speedlite toward the EOS 7D Mark II and turn its bounce head to illuminate your subject.

The drawback to optical wireless is its relatively limited range. You need to keep the Speedlite within 10m and 80° of the camera indoors, or 5m and 80° outdoors (the range decreases the greater the angle of the flash from the front of the camera).

To start using wireless flash set **Wireless func.** to an option other than **Disable** (see the list opposite for a description of the other options). To avoid triggering the wrong Speedlites (if another photographer is working in the same area, for example) you can assign a **Channel** number of between **1** and **4**. Both your EOS 7D Mark II and Speedlite need to be set to the same channel number (which should be different to the channel number of any Speedlite you don't want to fire).

Wireless func.	Options
⇒🔦 : 👞	Sets the built-in flash to trigger one external Speedlite. When this option is selected you can adjust **👞 exp. comp.** (affecting both the built-in flash and Speedlite), as well as **🔦 : 👞** (this is also known as the flash ratio: the balance in the strength of illumination between the built-in flash and the Speedlite—see below).
⇒🔦	When this option is selected, the built-in flash does not illuminate the subject: it only fires to trigger one or more Speedlite(s). If you're using multiple Speedlites, these can be split into a **Firing group** for greater control over lighting (see below).
⇒🔦 + 👞	This option allows you to use the built-in flash to trigger one or more Speedlites—and both are used to illuminate your subject. It's more flexible than ⇒🔦 : 👞 as you can adjust the exposure of the built-in flash and Speedlites by setting **👞 exp. comp.** separately for both. As with ⇒🔦, if you're using multiple Speedlites, these can be split into a **Firing group** for greater control over lighting.

Firing group	Options
🔦 All	Treats multiple Speedlites as one unit so the exposure settings are common to all.
🔦 (A:B [C])	Allows you to split multiple Speedlites into three groups (A, B, and C). You can alter the ratio between the two groups using **A:B fire ratio** (**Grp. C exp. comp** to adjust C).
🔦 All and 👞	Lets you set the **👞 exp. comp.** of the built-in flash and Speedlite(s) separately.
🔦 (A:B [C]) 👞	Lets you set the **👞 exp. comp.** of the built-in flash and grouped Speedlite(s) separately, as well as the A:B [C] fire ratio of the grouped Speedlites.

Other	Options
🔦 : 👞	Sets the ratio of the built-in flash to the Speedlite(s). 1:1 means that the power of the flashes is equal. 8:1 means that the Speedlite is fired at 1/8 of the power of the built-in flash.

5 » EXTERNAL FLASH

The hotshoe above the built-in flash allows you to attach an external Speedlite. The basic hotshoe is a standard design used by most camera manufacturers, although the electrical connections embedded in the hotshoe differ between brands (the central contact is common to all hotshoes, but all other contacts are proprietary). For this reason it's recommended that only flashes designed specifically for Canon cameras are fitted to your EOS 7D Mark II.

Canon produces five compatible Speedlites, referred to as the EX series. Usefully, the Canon model number divided by 10 gives you the GN of the Speedlite (in meters). Although Canon recommends that you don't use third-party flash units, companies such as Metz, Nissin, and Sigma produce flashes that are compatible with the EOS 7D Mark II (some even support functions such as wireless flash).

Certain Speedlite functions can be set using the **External flash func. setting** option found on the Flash control menu screen (see next page); while some functions may need to be set on the Speedlite itself.

Fitting an external flash
1) Make sure that both your EOS 7D Mark II and Speedlite are switched off.

2) Slide the Speedlite shoe into the hotshoe of the camera.

3) Turn the Speedlite on first, followed by the camera.

4) A ⚡ symbol will be displayed in the viewfinder, or on the rear LCD screen if you are in Live View.

5) To remove the Speedlite, switch off the camera and flash, and reverse the procedure in step 2.

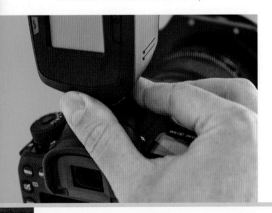

LOCKED **«**
If your Speedlite has a locking collar, press the locking button and slide the collar around until it clicks into the lock position.

› External flash settings

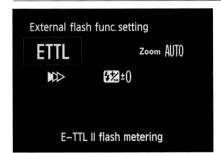

External flash func. setting

ETTL Zoom AUTO

E–TTL II flash metering

SPECIFICATIONS ⌃
The external flash functions available depend on the specifications of the Speedlite you use.

The External flash func. setting screen lets you set the shooting functions of compatible Speedlites in-camera, rather than on the Speedlite itself.

Changing External flash func. setting options

1) Fit your Speedlite as described on the previous page. Turn both your camera and the Speedlite on.

2) Select **Flash control** on the ◻ 1 menu, followed by **External flash func. setting**. Anything you change on this menu will be applied automatically to the Speedlite.

3) Select the function you want to change by using ✵ and then pressing ⑤ⓔⓣ. Select the required option by pressing ◄ / ► and then ⑤ⓔⓣ. Press ⑤ⓔⓣ to continue.

4) If you want to change the custom functions of the Speedlite, these can be altered by choosing the **External Flash C.Fn settings** submenu from **Flash control**. The available custom functions will vary between Speedlites.

5) Press MENU to return to the main ◻ 1 menu, or press lightly down on the shutter-release button to return to shooting mode.

> **Notes:**
> The functions of generic third-party flash units cannot be set using the **External flash func. setting** screen.
>
> With third-party flashes that are designed specifically for Canon EOS cameras. You may be able to set a limited range of functions using the **External flash func. setting** screen.

› Flash mode

As with the built-in flash setting screen, this option lets you set whether the flash uses E-TTL II metering or whether the exposure is determined manually. Other options may also be available, depending on the specifications of your Speedlite.

› Wireless functions

Sets the wireless function (either optical or radio) of your Speedlite.

› Flash zoom

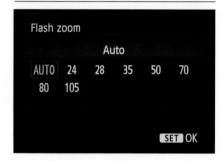

If your flash has a compatible zoom head, selecting **Auto** ensures that the flash coverage adjusts to match the focal length of the lens.

You can also adjust the flash coverage manually. This is necessary when you use a lens that doesn't supply the necessary focal length information for Auto zoom. It can also be done deliberately for creative effect: to focus the light from the flash at a particular point in the scene (typically your subject), leaving the area around the edge of the frame darker.

› Flash exposure bracketing

Bracketing with a Speedlite is similar in concept to standard exposure bracketing. It is not a feature you will find on every Speedlite—in fact, it's restricted to high-end Speedlites such as the 600 EX-RT (it's certainly not available when using the EOS 7D Mark II's built-in flash). Instead of the exposure for the ambient light altering, the Speedlite output is altered between shots. Bracketing can typically be applied in ⅓-, ½-, or 1-stop increments.

› Shutter synchronization

The various options on this screen let you set the curtain sync of the Speedlite, as described for the built-in flash earlier in this chapter. It also lets you set a mode that isn't possible with the built-in flash: High-speed Sync (or HSS).

The sync speed on a camera is the fastest shutter speed at which the light from a Speedlite evenly lights the entire sensor. On older, mechanical cameras, using a shutter speed faster than the sync speed would result in partial exposure of the image by the Speedlite. The sync speed of the EOS 7D Mark II is 1/250 sec.,

so to prevent partial exposure of the image you cannot set a faster shutter speed when a Speedlite is attached and active.

Although 1/250 sec. might seem like a restriction, often it isn't. Flash is most often used when ambient light levels are low, which means the resulting shutter speed is usually far lower than 1/250 sec. Where 1/250 sec. does become restrictive is when flash is needed as a fill light for backlit subjects in bright conditions. To solve this problem all of Canon's current Speedlites (with the exception of the 90EX) have an HSS mode that enables you to use shutter speeds up to 1/8000 sec. in combination with flash.

HSS works by pulsing the Speedlite's output to "build up" the exposure as the shutter curtains travel across the sensor. This effectively turns the flash into a continuous light source. However, in doing this, the power of the flash (and therefore its effective distance) is reduced, as the Speedlite has to discharge multiple times, rather than just once. As long as you keep your subject relatively close to the camera, HSS is an invaluable technique for creative flash photography.

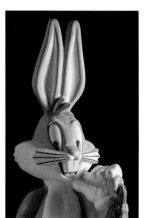

FLASH EXPOSURE BRACKETING ⌃
Flash bracketing allows you to shoot a sequence of exposures in which the power of the flash is varied between shots.

Although it is relatively small, Canon's Speedlite range features models to suit a wide variety of needs. The smallest, lightest, and the least powerful of these is the 90EX, which was designed originally for Canon's EOS M camera. Unusually for such a low-powered, low-specification Speedlite it can be used as a master flash to trigger other compatible flashes. However, as the EOS 7D Mark II's built-in flash can also perform this trick, the 90EX can be safely discounted.

A step-up in sophistication (and size, weight, and power) is the 270EX II. Although it is relatively small, it still features a zoom and bounce head, and rapid, near-silent recharging. It can be fired remotely by the EOS 7D Mark II's built-in flash, but unlike the 90EX it cannot be used as a master flash to fire other Speedlites.

The 320EX is Canon's mid-range Speedlite. For videographers, the most useful aspect of the 320EX is a built-in LED light that can provide a constant light source when shooting movies. In theory, this is a good idea, but in practice the light isn't that powerful, so your subject needs to be very close to the camera to be evenly illuminated. Like the 270EX II, the 320EX can be used as a slave flash, but does not have master flash capability.

The Speedlite 430EX II is a smaller, less powerful sibling to the top-of-the-range 600EX-RT. It can be used in the EOS 7D Mark II's hotshoe or as an off-camera slave flash, triggered by the EOS 7D Mark II's built-in flash. The 430EX II allows high speed, 1st, and 2nd curtain flash sync, and has comprehensive exposure compensation options.

The 600EX-RT is the largest, heaviest, and best-specified Speedlite model. It has integrated radio-triggering, as well as infrared wireless flash control, improved weather sealing, high-speed sync, and 18 custom functions.

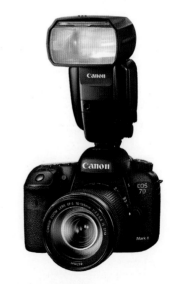

SPEEDLITE 600EX-RT ⌃

	90EX	270EX II	320EX	430EX II	600EX-RT
GN @ ISO 100	29ft/9m	89ft/27m	104ft/32m	141ft/43m	196.9ft/60m
Tilt/swivel	No	Tilt only	Yes	Yes	Yes
Focal length coverage*	24mm	28–50mm	24–50mm	14–105mm	14–200mm
AF-assist beam	Yes	Yes	Yes	Yes	Yes
Flash metering	E-TTL/ E-TTL II	E-TTL/ E-TTL II	E-TTL/ E-TTL II	E-TTL/ E-TTL II	E-TTL/ E-TTL II/ TTL/Manual
Approximate recycling time	5.5 seconds	0.1–3.9 seconds	0.1–2.3 seconds	0.1–3.7 seconds	0.1–5.5 seconds (0.1–3.3 seconds using quick flash)
Batteries	2 x AAA/LR03	2 x AA/LR6	4 x AA/LR6	4 x AA/LR6	4 x AA/LR6
Dimensions (w x h x d)	1.7 x 2 x 2.5in./44 x 52 x 65mm	2.5 x 2.6 x 3.0in./64 x 65 x 72mm	2.75 x 4.5 x 3.09in./70 x 115 x 78.4mm	2.8 x 4.8 x 4.0in./72 x 122 x 101mm	3.1 x 5.6 x 4.9in./79.7 x 142.9 x 125.4mm
Weight (without batteries)	1.8oz/50g	5.1oz/155g	9.7oz/275g	11.6oz/320g	15oz/425g
Other information	–	HSS	HSS	HSS, 1st and 2nd curtain sync	HSS, 1st and 2nd curtain sync

*Full-frame equivalent

5 » FLASH TECHNIQUES

› Bounce flash

Fired directly from its perch on top of your EOS 7D Mark II, the light from a Speedlite isn't very flattering. An immediately more satisfying light is produced by "bouncing" light down onto (or across) your subject. All of the current Speedlites (with the exception of the 90EX) allow you to angle the flash head upward (and sideways on some models) to bounce it.

The technique requires a suitable neutral-colored surface near your subject. Typically this would be a wall or ceiling, but if you have help, someone holding a large reflector in the right place is even more effective.

The light from a flash is a point light source, which means it is relatively small in comparison to the subject being lit. This creates high contrast, with bright highlights and deep shadows that have sharply defined edges. By bouncing the light, the area that the light appears to emanate from is increased. This has the effect of softening the light and reducing contrast. Softer light makes shadows less hard, and the transition from light to dark is more attenuated.

One aspect to be aware of when using bounce flash is that you increase the flash-to-subject distance. E-TTL II should adjust for this automatically, but you will need to take it into account if you're setting the flash exposure manually. There's also a risk that your image will be underexposed if the Speedlite is insufficiently powerful, or if you use too small an aperture, reducing the effective flash distance.

Tip

If the surface you bounce the light from isn't neutral in color then the light from the Speedlite will reflect this color onto your subject.

BOUNCED ⌃

Images of people, animals, or toys can look more like police mugshots when direct flash is used (above left). Bouncing light produces much softer shadows and a more pleasing lighting direction (above right).

Strictly speaking, a macro lens is one that can project an image onto a sensor that is life size or larger (if you were able to measure the projected image of your subject on the sensor it would be exactly the same size or larger than the subject itself). A life-size image is said to have a reproduction ration of 1:1, twice life size is 2:1, and so on. The 18–135mm STM kit lens commonly bundled with the EOS 7D Mark II can focus down to 15 inches (39cm), but the projected image only has a reproduction ratio of 1:4 (1/4 life size). This is good for a general-purpose lens, but strictly speaking it is not macro.

The reproduction ratio is one of two ways that manufacturers show the macro capabilities of a lens; the other is the magnification figure. Unfortunately, lens manufacturers generally use one or the other, but rarely both. To convert a reproduction ratio to a magnification figure, divide the number on the left of the reproduction ratio by the number on the right (so 1:4 would give a magnification figure of 0.25x). To convert in the other direction, divide 1 by the magnification to get the figure that should be placed on the right side of the reproduction ratio.

LEAVES ⌃»

The difference between close-up and macro can be seen in these two shots of leaves. The close-up image (above) was shot with a 200mm lens—it shows context, but little of the structure of the leaves themselves. The macro image (opposite) has no context and is more abstract. The structure of the leaf is very visible.

6 » MACRO SOLUTIONS

There are two ways to shoot macro imagery: temporarily adapt a "normal" lens so that it can focus more closely than it is designed to, or invest in a dedicated macro lens. This section covers the first possibility, describing the relatively simple equipment involved. This equipment will not give you the image quality of a true macro lens, but is a relatively inexpensive entry into the world of macro photography.

› Close-up attachment lenses

The easiest way to make a lens focus more closely is to fit a supplementary close-up attachment lens. Close-up attachment lenses screw onto the filter thread at the front of the lens and work by reducing the minimum focusing distance of the lens. They're easy to use because they don't interfere with either the autofocus or exposure system of the camera.

Close-up attachment lenses are available in a variety of strengths, which is indicated by a diopter value: the higher the value, the greater the lens' magnification. It is also possible to stack close-up lenses to increase the magnification, although image quality will drop noticeably. For optimum quality it is best to use a single close-up attachment lens and to attach it to a prime lens, rather than a zoom.

Canon currently produces two close-up attachment lenses: a +2 diopter (Type 500D) to fit 52mm, 55mm, 72mm, and 77mm filter threads, and a +4 diopter (Type 250D) for 52mm and 55mm filter threads.

APERTURE ⌃
The limited depth of field you get when shooting macro images invariably means using very small aperture settings, even when using close-up attachment lenses or extension tubes.

› Reversing ring

It might sound odd, but if you mount a lens backward on your EOS 7D Mark II, it will instantly become a macro lens. The practical problem is keeping the lens attached to the camera, although the simple solution to this comes in the form of a "reversing ring." A reversing ring is a very simple device: one side has a bayonet mount that fits the lens mount of your camera (like a lens); the other side is a screw thread that allows you to attach a lens to it using the lens' filter thread (you therefore buy a reversing ring with a thread size that matches the filter thread of the lens you want to use).

There are a few downsides to using reversing rings. The first is that they don't usually carry a signal from the lens to the camera, so AF will be disabled. It also means that there's no way to set the aperture on the lens. The easiest way to overcome the latter problem is to use a manual lens with an aperture ring. Canon used to produce lenses like this for its pre-EOS, FD-mount cameras. FD lenses are in plentiful supply secondhand and can be bought very cheaply.

To use a reversing ring, set the mode dial on your EOS 7D Mark II to **M** once the lens has been attached to the camera. Then, set the shutter speed as normal and adjust the aperture ring until the correct exposure is obtained.

RINGED ⌃
A reversing ring with a 58mm thread allows me to use an old Minolta 50mm manual focus lens with my EOS cameras.

› Extension tubes

Extension tubes (also known as extension rings) are hollow tubes that fit between the camera and a lens. This decreases the minimum focusing distance of the lens and increases its magnification. As there is no glass in the extension tube, there is

very little loss of image quality. Extension tubes manufactured by third-party manufacturers are often sold in sets of three rings of different lengths. These rings can be detached and used separately, or combined to increase the magnification.

Unfortunately, cheaper extension tubes generally don't maintain a connection between the lens and the camera. As with reversing rings, this means that AF is disabled, as is aperture control.

Canon currently produces two extension tubes: the EF 12II and the RF/25II. The first extends the lens by 12mm, the second by 25mm. Both extension tubes retain AF and aperture control of the lens.

However, Kenko (a third-party manufacturer of photographic products) produces probably the most popular extension tubes, which also allow the use of AF and aperture control.

› Bellows

Bellows work on the same principle to extension tubes, but as they are extended or compressed along a guide rail it is easier to set the desired magnification. Once this is achieved, the bellows can be locked in position, ready for shooting.

The downside to using bellows is that they are heavier and more cumbersome than extension tubes. Most bellows systems are therefore used in studios, with the setup mounted on a tripod.

Bellows are also far more expensive than extension tubes—Canon doesn't make bellows for the EOS system itself, but compatible systems can be bought from companies such as Novoflex.

KENKO EXTENSION TUBE SET ≫
Kenko's popular extension tube set provides 68mm of extension when the tubes are combined or 12mm, 20mm, and 36mm of extension when used individually.

WORKING DISTANCE

The working distance of a macro lens is the distance from the lens to the subject that is needed to achieve the required reproduction ratio. The longer the focal length of a macro lens, the greater the working distance will be, so the working distance of a 50mm macro lens is half that of a 100mm lens, and one quarter that of a 200mm lens at a 1:1 reproduction ratio.

There are numerous advantages to using a long focal length macro lens. The first is that the greater working distance means you won't disturb your subject by knocking it with the lens—if your subject is an animal you will be less intimidating.

It's also easier to arrange lighting to illuminate your subject sympathetically—a short working distance means there's less space to fit a light or reflector between the camera and the subject. It also increases the risk that you or the camera will cast a shadow over the subject.

Finally, the further you get from your subject, the more natural the perspective will be.

The downside to using a longer focal length macro lens is that it will be inevitably heavy and cumbersome to use. Long focal length macro lenses are also far more expensive than those with a shorter focal length. Therefore, choosing a macro lens involves thinking about your budget and what your primary subjects are likely to be.

BREEZE ⌃
Delicate subjects, such as flowers, don't even need to be touched to cause unwanted movement—the breeze caused as you move around them is enough. Long focal length macro lenses help reduce that risk.

6 » SHARPNESS

Shooting macro subjects outdoors can be a challenge, especially when shooting delicate subjects that will move in the slightest breeze. To overcome that problem for this shot I set the ISO to 400 to allow a shutter speed that was fast enough to freeze the movement. Even so, I still had to use a large aperture, which meant that focusing had to be precise, due to the extremely narrow depth of field.

Settings
> Focal length: 50mm
> Aperture: f/4
> Shutter speed: 1/100 sec.
> ISO: 400

MACRO LENSES

Canon lenses

Canon currently produces five fixed focal length macro lenses that offer 1:1 magnification. All but one of these lenses (the MP-E 65mm) can also be used for non-macro photography.

The EF-S 60mm f/2.8 Macro USM can only be used by cropped-sensor cameras, such as the EOS 7D Mark II. At the time of writing it is Canon's only macro EF-S lens. It is also the smallest and lightest macro lens in the company's range.

The quirkiest macro lens is Canon's MP-E 65mm f/2.8 1–5x Macro. This lens has a 5:1 reproduction ratio, allowing you to capture macro images that are five times life size. This lens is manual focus only, although it's often easier to mount the camera and lens on a rail system and move the combination backward and forward to achieve critical focus.

Canon currently also produces two 100mm macro lenses. The newest version is an update of the original, featuring improved optics (achieving L-series status in the process) and the addition of Hybrid IS. The Hybrid IS system is designed to be effective when shooting macro images, something that rarely applies to older IS systems.

The largest, heaviest, and most expensive Canon macro lens is the EF 180mm f/3.5L Macro USM. With the longest working distance of all Canon's macros, this is the perfect lens when working with subjects that benefit from you keeping your distance.

> **Note:**
> Canon also produces the EF 50mm f/2.5 Compact Macro. However, despite the name this is not a true macro lens, as it only has a reproduction ratio of 1:2.

CANON EF 100MM ⌃

Canon is not the only manufacturer of macro lenses that are compatible with the EOS 7D Mark II. There are many third-party alternatives that are less expensive and sometimes optically the equal of Canon's offerings. The list below details the current range of lenses produced by Sigma, Tamron, and Tokina for Canon's EF-S lens mount.

Lens	Minimum focusing distance (cm)	Reproduction ratio	Filter thread size (mm)	Dimensions (diameter x length; mm)	Weight (g)
Sigma					
50mm f/2.8 EX DG	19	1:1	55	71.4 x 66.5	320
70mm f/2.8 EX DG	25	1:1	62	76 x 95	527
105mm f/2.8 APO EX DG OS HSM	31	1:1	62	78.3 x 126.4	725
150mm f/2.8 EX DG OS HSM	38	1:1	72	79.6 x 150	1150
Tamron					
60mm f/2 Di II LD SP AF	23	1:1	55	73 x 80	390
90mm f/2.8 SP Di	29	1:1	55	71.5 x 97	405
180mm f/3.5 SP Di	47	1:1	72	84.8 x 165.7	920
Tokina					
35mm f/2.8 AT-X PRO DX	14	1:1	52	73.2 x 60.4	340
100mm f/2.8 AT-X	30	1:1	55	73 x 95.1	540

» LIGHT

Lighting is as important for macro subjects as it is for larger subjects. This fly was captured walking across a window. In order to illuminate the fly and avoid overexposing the background I used off-camera flash. This allowed me to position the flash at the correct distance and at the right angle to produce a pleasing result.

Settings
> Focal length: 100mm
> Aperture: f/22
> Shutter speed: 1/125 sec.
> ISO: 800

7 ACCESSORIES

Accessories help you get the most out of a camera, either by making life easier or by expanding your camera's potential.

Although you will start with a camera and a lens or two, somehow that's never enough. One of the reasons that Canon EOS cameras are so popular is because they are one component in a mature system that has grown over the past 30 years. Canon sells numerous accessories that can either be used across its camera range or are designed for specific cameras, such as the EOS 7D Mark II. Some of these accessories are described later in this chapter.

There is also an astonishing number of third-party companies that produce accessories that can be used with the EOS 7D Mark II. These include companies that make equipment such as filters and tripods, some of which are also described in this chapter.

The key to choosing accessories is to decide what kind of photographer you are and identify the accessories that will genuinely help you—some accessories may be fun initially, but if they don't suit your style of photography they'll probably end up languishing at the bottom of a cupboard.

WFT-E7 ⌃
Canon's WFT-E7 wireless transmitter works with a number of EOS camera models, including the EOS 7D Mark II. It allows you to transmit files wirelessly to a computer. It's ideal if you're a sports or journalistic photographer, as you will be able to upload photographs to news agencies (or similar) as you shoot. However, for other types of photography—landscape photography, for example—it would be far less useful.

COMBINATION »
Some subjects require the use of several different accessories. This shot was created using a tripod, a polarizing filter, and a 2-stop ND graduated filter.

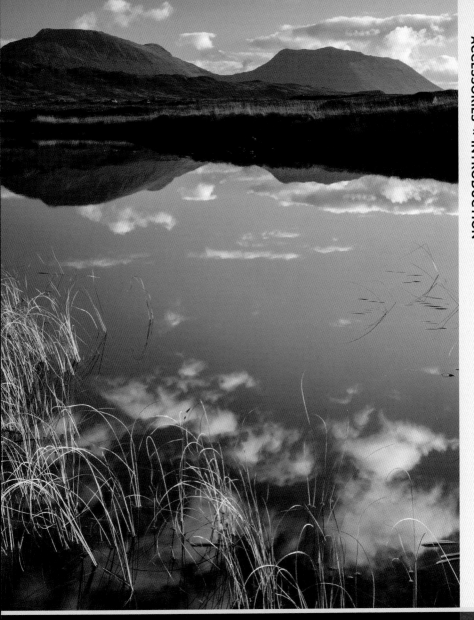

7 » FILTERS

Filters aren't necessarily relevant to all types of photography—wedding photographers typically wouldn't use filters, for example—but for genres such as landscape they're almost essential.

A filter is simply a sheet of glass, gelatin, or optical resin that is designed to affect the light that passes through it in some way. Filters are available in two different forms: round and threaded (so the filter can be screwed to the front of a lens), or square/rectangular (so that it can be slotted into a filter holder attached to the lens).

Which type you choose depends on how important you think filters will be to your photography. A filter holder system—although initially more expensive—is a far more adaptable and expandable way of using filters than the threaded kind.

Probably the best-known filter holder system manufacturer is Cokin, which produces four sizes of filter holder: the A system (67mm filters); the P system (84/85mm filters); the Z-Pro system (100mm); and the X-Pro system (120mm). Although the smaller filter holder systems are less expensive, they can cause vignetting at the corners of images, particularly when used with wide-angle lenses, making 100mm filters a better option.

Alternative manufacturers to Cokin are Lee Filters and Hi-Tech—both companies produce 100mm filter holders and filters.

All three systems use inexpensive adaptor rings that allow you to use the same filter holder on any lens.

› UV and skylight filters

UV and skylight filters absorb the ultraviolet light that is typically found at high altitude and on hazy days. This UV light can cause a distinctive blue cast in an image. Skylight filters have a slightly pink tint to them, helping to warm up the image, while UV filters are more neutral.

As neither filter affects exposure, they are often kept permanently attached to a lens to protect the front element from damage. Dedicated "protection" filters are also available for this purpose.

LEE FILTERS ⌃
A Lee Filters 100mm filter holder with an optional attachment ring for a 105mm polarizing filter.

› Neutral density (ND) filters

Each generation of imaging sensor sees an improvement in high ISO performance. This is great if you're a photographer who often works in marginal light, but still needs to use fast shutter speeds.

However, it's sometimes necessary to use longer shutter speeds. In good light this can be difficult to achieve, even when you are using the smallest aperture on the lens and the camera is set to its base ISO. Fortunately, there is a solution: neutral density (or ND) filters.

ND filters are semi-opaque and block some of the light that passes through the filter (essentially simulating shooting in low light). ND filters are available in a variety of strengths, from 1-stop (which is equivalent to halving the ISO speed) to very dense 10- or 12-stop filters (although this latter type is often not truly "neutral," requiring the creation of a custom white balance).

As long as the filter isn't too dense, the EOS 7D Mark II's exposure and AF systems should both be able to cope with an ND filter without a problem. If the AF system struggles—and this is inevitable when a 10- or 12-stop ND filter is used—focus before fitting the filter and then switch to MF so that focus doesn't shift when the filter is fitted. In good light, Live View AF is sometimes able to cope, even when very dense filters are used, but having a lens with a large maximum aperture is helpful.

Tip

ND filters are often sold using an optical density figure. A 1-stop ND filter has an optical density of 0.3, a 2-stop filter has an optical density of 0.6, and so on.

WATER ❯❯
Extending the shutter speed to blur flowing water is a common use for an ND filter. This shot required a 5-stop filter to increase the shutter speed to 3 sec.

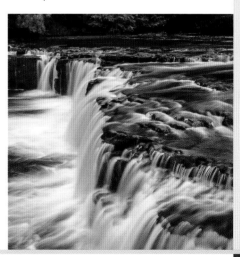

When light hits the surface of a non-metallic subject the rays of light are scattered randomly. This causes a noticeable glare on the surface of the subject and an apparent reduction in its color saturation. Light that's been scattered in this way has been polarized. To remove this glare and restore saturation a polarizing filter, or "polarizer," can be used. The effect is most readily seen on glossy surfaces such as water, shiny paint, and even wet or glossy leaves on trees. The reduction in glare is most effective when the camera/polarizer combination is used at approximately 35° to the surface of your subject.

Another effect of using a polarizer is the deepening of a blue sky. This effect is strongest when the polarizer is aimed toward the sky at 90° to the sun, with the effect diminishing noticeably at a smaller or larger angle than this. The height of the sun also affects how strongly a polarizing filter appears to work.

Polarizers are made of glass mounted in a holder that can be rotated through 360°, which allows the strength of the polarizing effect to be varied. A polarizer is slightly opaque, so will reduce the amount of light reaching the sensor. The exposure meter in the EOS 7D Mark II should automatically compensate when a polarizer is fitted, but if you're shooting in **M** or **B** modes you will need to compensate the exposure manually. The amount of compensation required will depend on the strength of the polarizing effect, but +2 stops is generally a good starting point.

Tips

Polarizing filters come in two forms: linear or circular. For technical reasons linear polarizers are only really suitable when using a lens set to MF or when using Live View AF. This makes them less useful than circular polarizers, which is the recommended type.

Avoid using a polarizer with a wide-angle lens to deepen a blue sky, as the polarizing effect will not apply equally to the entire sky. As a result, it's often possible to see a polarized "band" across a wide-angle image.

SKY ⌃

Deepening the blue of a sky with a polarizer is generally more pleasing when there are clouds present. Clear skies that have been polarized generally appear "overcooked" and unnatural.

7 » SUPPORTING THE CAMERA

› Tripods

The high ISO capabilities of the EOS 7D Mark II could fool you into thinking that you no longer need a tripod, but for certain techniques—such as when deliberately shooting long-exposure images—a tripod is as necessary as ever. Apart from its practical benefits, a tripod will also force you to slow down and this in turn will encourage you to think more about your photography.

The EOS 7D Mark II is a reasonably weighty camera, especially when an L-series zoom lens is fitted. This means it's important to choose a tripod that's up to the task of supporting the camera without becoming unstable. Choose a tripod that can be raised to a reasonable height without the use of its center-column if possible, but at the same time don't pick a tripod that's so heavy you'll be discouraged from carrying/using it. There's a definite compromise between weight and stability: carbon fiber tripods generally offer the best balance of weight and stability, but they are usually far more expensive than a plastic or aluminum equivalent.

Usually, cheaper tripods are sold as a single unit, so the head is attached permanently to the legs. However, although it will be more expensive, it's worth buying a tripod without a head,

and then purchasing the head separately. This allows you to choose a head that best suits your preferred style of photography.

There are three main types of tripod head. Ball heads are light, but strong, although they can be fiddly when small adjustments are required. Three-way heads are simple to use, as the head is adjustable in three different directions, each of which can be locked independently. Geared heads are the easiest to make fine adjustments to, although the geared mechanism generally makes them heavier than either a ball or three-way head. Although tripod manufacturers generally make both legs and heads there's no reason not to mix and match, using one manufacturer's head with another's legs.

› Other supports

A useful alternative to a tripod is a monopod. As the name suggests, a monopod has just one leg (although like a tripod this leg is usually extendable). Monopods are less stable than a tripod, so you wouldn't use one when shutter speeds are measured in whole seconds, but at moderately slow speeds they still offer far more support to a camera than handholding alone. Some monopods can also be used as walking

poles, which is useful if you're a landscape photographer who regularly climbs hills.

A beanbag is another useful item to keep in your kit bag. It will allow you to rest your camera on a flat surface, such as a wall, and help to prevent scratches to the base of your camera, as well as damping down vibrations.

ANTICIPATION ⌄

Tripods take time to set up. For time-critical subjects—such as shooting weather-related events in the landscape—it pays to be set up ahead of time and then to wait for the event to happen.

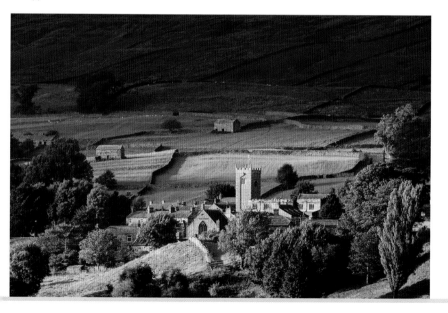

7 » OTHER ACCESSORIES

› Remote switches

A remote switch allows you to fire the shutter without touching the camera when it's mounted on a tripod. This helps to reduce the risk of camera shake caused by the action of pressing down on the shutter-release button. Canon currently sells three remote switches that are compatible with the EOS 7D Mark II.

The wired RS-80N3 is a simple remote switch that allows you to both fire and lock the shutter open (the latter option is necessary when shooting Bulb exposures).

The TC-80N3 adds a timer facility, which allows you to shoot images at intervals, set automatic long exposure or self-timer images, and set the EOS 7D Mark II to fire a set number of exposures (although this is less necessary with the EOS 7D Mark II as it has a built-in intervalometer function).

The RC-6 remote release uses an infrared beam to trigger the shutter. Again, the RC-6 is a simple device, with functions limited to firing the shutter immediately or after a 2-second delay (when the drive mode is set to 📱⏱ or 📱⏱2. The two drawbacks to the RC-6 are its limited range and the fact that you need to maintain line of sight between the camera's infrared sensor (in the grip at the front of the camera) and the remote switch.

› Battery grip

Canon's BG-E16 battery grip has both ergonomic and practical benefits. In terms of ergonomics, many of the camera's controls are mirrored on the grip, allowing you to hold your camera in the same way, whether you are shooting horizontally or vertically.

The grip also allows you to use two LP-E6N or six AA batteries to power your EOS 7D Mark II for extended shooting sessions. The latter option is particularly useful if you're away from home, can't recharge the LP-E6N batteries, and have to rely on batteries on sale locally.

BATTERY GRIP BG-E16 ⌃

Microphones and headphones

If you regularly use your EOS 7D Mark II to shoot movies, it's a good idea to invest in a good quality microphone and set of headphones. An external microphone can be positioned away from the camera (out of range of any noises made by the camera) and closer to your subject. If the microphone has a foam cover this will help to reduce the effect of wind noise, as well as protecting the microphone head itself.

The headphones will let you monitor sound more effectively, allowing you to listen out for any distracting sounds that may be missed and that would otherwise mar the soundtrack (you would then have the option of re-recording if necessary—an option that may not be available if you don't review the footage until it's imported onto your computer).

› AC adaptor

You can power your EOS 7D Mark II using the optional ACK-E6 AC adaptor kit. This is particularly useful when you are using your camera to display images or movies on a TV, or when you are transferring a large number of files to your computer or printer.

To use the adaptor, turn the camera off and then plug the power cord of the AC-E6 adaptor into the DR-E6 coupler. Open the battery cover on the camera and slide the coupler into the camera as if you are replacing the standard battery. The coupler should click into place. Close the battery cover, slotting the power cable into the DC coupler cord hole.

Plug the power cord into the AC adaptor and then connect to a convenient wall socket. Turn the camera on and use it as normal. To remove the AC adaptor, turn the camera off and reverse the process.

CONNECTED **«**
Microphones designed for use with DSLRs generally come with a mount so they can be attached to the hotshoe of a camera. Another useful accessory associated with microphones is a "dead cat." This is a cover that fits over the microphone to reduce the distracting noise of wind when recording outdoors.

Shooting architectural subjects—particularly in a relatively formal way—requires the use of a tripod. It takes time to set up a shot in which the verticals are perfectly vertical, and this is something that can't be achieved easily when handholding a camera.

Settings
> Focal length: 100mm
> Aperture: f/16
> Shutter speed: 30 sec.
> ISO: 200

» PREPARATION

Successful photography often requires preparation. For landscape photography this means knowing when and where the sun—and the moon—will rise and set. There are plenty of invaluable apps on Smartphones and tablet computers that provide this information. This shot of a rising moon would have been far more difficult if I hadn't been able to work out the practical details beforehand.

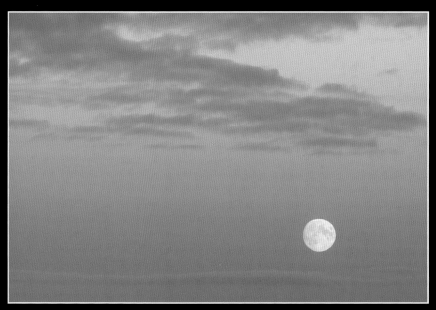

Settings
> Focal length: 200mm
> Aperture: f/8
> Shutter speed: 1/10 sec.
> ISO: 200

8 CONNECTION

If you want to make the most of your EOS 7D Mark II you'll ultimately need to connect it (or the memory card) to an external digital device, such as a computer, printer, or even a television. This will enable you to archive, review, edit, and print your images.

› Color calibration

Once your images have been copied to a computer, the precision with which colors are displayed and printed depends on your color calibration regime.

There are two devices that commonly need calibrating: your computer monitor and your printer (or, to be more accurate, how colors translate to a particular type of paper). Modern monitors are generally very stable devices, but over time the color of a monitor will drift. To keep track of this drift, and to ensure your colors remain accurate, you need to calibrate your monitor at regular intervals.

Hardware monitor color calibrators are readily available from most good retail and online electronics stores. Depending on the calibration tool you use, calibrating a monitor takes 5–10 minutes, although the process is best performed after the monitor's been in use for more than 30 minutes, so it is fully warmed up. Good image-editing software will use the monitor profile created by the calibrator to ensure that you're viewing accurate colors on screen.

To make prints from your images you will also need an accurate profile for the particular type of paper you want to use with your printer. A profile specifies how the printer needs to modify its output so that a particular paper type receives the correct amount of ink in the right proportions to reproduce an image's colors accurately.

Most paper manufacturers supply profiles for their papers for popular printers, but a specially created profile for your personal printer and paper combination will be far more accurate. Creating a printer profile also requires a hardware calibrator (although this is a different type to a monitor calibrator), although if you only use a few different types of paper there are companies who will create bespoke profiles for a nominal fee, which may prove more cost efficient.

BLACK AND WHITE »
Black-and-white images also require a color-calibrated system, to ensure that the range of tones in the image are displayed and printed accurately.

8 » CANON SOFTWARE

Your EOS 7D Mark II is bundled with Digital Photo Professional (DPP), EOS Utility 2, ImageBrowser EX, Picture Style Editor, and PhotoStitch software. It's not obligatory to use these programs (commercial alternatives are available, such as Adobe Lightroom, for example), but the various packages are an inexpensive way to start organizing and adjusting the images from your camera.

There is not enough space in this book to give an in-depth guide to all this software, but comprehensive manuals are supplied in PDF format on the disk that came with your EOS 7D Mark II. To install the software, follow the instructions below.

If using Windows:

1) Log in to your computer as normal (or as the Administrator if you are required to do so to install software).

2) Insert the Canon CD-ROM disk into the CD-ROM drive.

3) The Canon software installation screen should appear automatically. Click on **Easy Installation** to install all the software automatically, or click on **Custom Installation** to choose which of the programs you want to install. Follow the on-screen instructions to continue.

4) When the installation is complete, click on either **Finish** or **Restart** as required.

5) Remove the CD-ROM.

Warning!

The software is only compatible with Windows 7, 8, and 8.1, and Intel Mac OS X v10.8—v10.10.

Uninstall any previous versions of ZoomBrowser or ImageBrowser from your computer before installing the new software.

If using Mac OS X:

1) Log in to your computer as normal (or as the Administrator if this is necessary to install software).

2) Insert the Canon CD-ROM disk into the CD-ROM drive.

3) Double-click on the CD-ROM icon on your Mac's desktop.

4) Double-click on Setup. The Canon software installation screen should now appear. Follow the on-screen instructions to select your geographical region and country. On the Selecting an Installation

Type screen, click on **Easy Installation** to automatically install all the software on the disk, or **Custom Installation** to select the programs you want to install. Follow the instructions on screen to continue.

5) When installation is complete, click on **Restart** (your Mac must be rebooted before you can begin using the software).

6) Once your Mac has rebooted, the installed software can be found in the Applications folder of your Mac hard drive. Launch icons will have been added automatically to the dock.

INSTALLATION ☒
Installing the software on Mac OS X.

Notes:
The latest iMacs don't have optical drives. This means you will need to download and install the software from your local Canon web site or purchase an external optical drive.

You can register for CANON iMAGE GATEWAY during installation. This is a free service that allows you to post your images and videos online for other members to view. As well as this facility there are technique articles to read and benefits such as free shipping when products are purchased through the Canon online store.

Digital Photo Professional

DPP is Canon's postproduction software, which can be used to adjust and convert your EOS 7D Mark II's .CR2 Raw files to JPEG or TIFF, or to transfer the files directly to other software, such as Adobe Photoshop. If you've set **Dust Delete Data** (see page 100) you would use DPP to automatically clone out dust spots.

EOS Utility 2

This very useful utility automates the importing process, making it easy to get your images onto your computer. It can be used to organize the images on your memory card and for tethered shooting (see page 232).

Picture Style Editor

Picture Styles can be edited, saved, and then copied to your EOS 7D Mark II for use when shooting still images and movies.

ImageBrowser EX

ImageBrowser EX is used to sort your images on your computer. The simple interface allows you to quickly copy, duplicate, move, rename, or delete images and movie files. You can also rate them using a star system.

PhotoStitch

One way to create high-resolution panoramic imagery is to shoot a short sequence of images across a scene (typically moving from left to right and overlapping details in the scene). The sequence is then joined together in postproduction using specialist software, such as PhotoStitch, which stitches image sequences together automatically.

IMAGEBROWSER EX ⌄
The key to keeping track of your image collection is to use a logical and expandable filing system of folders.

› CONNECTING TO A COMPUTER

1) Lift up the flap covering the Digital and HDMI out terminals. Screw the cable protector firmly in place.

2) Push the head of the USB cable through the cable protector and into the Digital terminal. It will only fit one way so do not force it if it doesn't slide easily into place.

3) Insert the other end of the USB cable into a USB port on your computer.

4) Turn on your camera.

5) On Windows computers click on **Downloads Images From EOS Camera using Canon EOS Utility**. Canon EOS Utility should now launch automatically. Check **Always do this for this device** if you want to make this the default action when you connect your camera.
 If you are using Mac OS X, EOS Utility should run automatically when you attach your camera.

6) Follow the on-screen instructions for EOS Utility.

7) Quit EOS Utility when you're finished and turn off your camera. Unplug the USB cable from the camera and your computer, and unscrew the cable protector.

Warning!

Before connecting your EOS 7D Mark II to your computer, install the Canon software. You should also ensure that the camera is switched off and its battery is fully charged.

CONNECTED ❯❯
Canon's new cable protector and USB attached to the EOS 7D Mark II.

8 » TETHERED SHOOTING

Connecting your EOS 7D Mark II to a computer lets you use a technique known as "tethered shooting." After you connect your camera to your computer using a USB cable, you can display a Live View image on your computer monitor in EOS Utility. The software lets you make adjustments to the camera settings—including exposure and white balance—before you take a shot. The resulting image is then transferred directly to your computer for saving.

The main drawback with tethered shooting is that you're limited to shooting within a USB cable's range of your computer. This makes the technique more difficult away from the studio, but it is not impossible with a suitable laptop or tablet computer.

Enabling tethered shooting

1) Connect your EOS 7D Mark II to your computer, as described on page 231.

2) Launch EOS Utility (if it doesn't automatically launch) and click on **Camera Setting/Remote Shooting**.

3) Click **Preferences** and select **Destination Folder** from the pop-up menu (Mac) or tab (Windows) at the top of the dialog box. Select the folder you want your images to be saved to. Alter the other settings as desired.

4) Select **Linked Software** from the pop-up menu (Mac) or tab (Windows) at the top of the dialog box. Select the software that you want to use to edit the captured images.

5) Click **OK** to continue.

6) Click the **Live View shoot...** button to see the camera's output on your computer's screen.

7) Alter settings such as **White Balance** and **Focus**—found to the right and below the Live View window—as required.

8) Click on the EOS Utility shutter-release button to capture the image.

9) When you're done, disconnect your camera from your computer, as described on page 231.

DETAIL ⌃
Tethered shooting is ideal for close-up photography, as you're better able to see what's in or out of focus.

EYE-FI

Eye-Fi is a proprietary SD memory card with a built-in Wi-Fi transmitter. This allows you to transfer files wirelessly between your EOS 7D Mark II and a Wi-Fi-enabled computer or hosting service. To set up the Eye-Fi card check the manual that came with your card before use. For more information about Eye-Fi go to www.eye.fi.

Enabling Eye-Fi
1) Select **Eye-Fi Settings** on the ♥ 1 menu.

2) Set **Eye-Fi trans.** to **Enable**. When **Eye-Fi trans.** is set to **Disable** the Eye-Fi card won't automatically transmit your files and 📶OFF will be shown.

3) Shoot a picture. The Eye-Fi symbol turns from a gray 📶 to one of the other icons shown below. When an image has been transferred, 🖼 will be displayed on the shooting information screen.

Displayed symbol	Status
📶 [GRAY]	Not connected
📶 [BLINKING]	Connecting
📶 [SOLID WHITE]	Connection to access point established
📶(↑)	Transferring

Checking an Eye-Fi connection
1) Select **Eye-Fi Settings** on the ♥ 1 menu.

2) Select **Connection info**. The connection information screen will be displayed.

3) Press MENU to return to the main Eye-Fi Settings menu.

> **Notes:**
> File transfer speeds from an Eye-Fi card are dependant on the speed of your wireless connection.
>
> The EOS 7D Mark II's battery may be depleted more quickly than usual when Eye-Fi is used.
>
> Eye-Fi settings will only appear on the ♥ 1 menu when an Eye-Fi card is installed.
>
> Make sure the write-protect tab on your Eye-Fi card is set to unlocked.

EYE-FI CARD «
© Eye-Fi, Inc.

For studio-based photographers, the EOS 7D Mark II's built-in GPS will have little appeal, but if you're a landscape or location photographer you will find it is a very useful tool for automatically keeping track of where shots were made. The GPS system also allows you to display a digital compass on the LCD screen, which can be used to orientate your camera to a particular direction or help you visualize where the sun or moon will rise or set.

When GPS is enabled (and a signal has been acquired) longitude, latitude, and elevation data is appended to the metadata of your files as you shoot. This is known as geotagging. The location information can then be read and used by suitable software (such as Canon's Map Utility application) either as another way of sorting images or to display the shooting location on a map. If you're traveling, you can also set a logging function on your EOS 7D Mark II. The logging information can be used by Map Utility to build up a route showing how you traveled from place to place during your travels.

Switching on and setting up GPS

1) Select **GPS/digital compass settings** on the ♥ 2 menu.

2) Choose **GPS**, then highlight **Enable** and press (SET).

3) Select **Set up**.

4) Setting **Auto time setting** to **Auto update** will update the internal clock of your EOS 7D Mark II automatically using GPS time data whenever your camera is

switched on and a GPS signal is acquired. You can also force the internal clock to update immediately by choosing **Set now** (but only when five or more satellites have been found by the internal GPS). Select **Disable** to stop the GPS system updating the internal clock.

5) You can select how often the GPS receiver in the EOS 7D Mark II acquires a position update by selecting **Position update intvl** and selecting one of the available time intervals. The more often the location information is acquired, the more accurate the location data embedded in image metadata will be. However, acquiring GPS information is a drain on the camera's battery, so if you're not moving around much use a longer period of time to be more power efficient.

6) Select **GPS Logger** to start the logging function. When logging is activated, **LOG** is displayed on the rear LCD screen if the shooting information screen is displayed and when the camera powers down or is switched off (when activated, logging only stops if you take the camera's battery out). Log files are stored in the EOS 7D Mark II's internal memory and can be copied to a computer using EOS Utility or you can choose to **Transfer log data to card** to copy it to the currently active memory card (where it will be stored in the MISC folder as a file with the suffix .LOG). Select **Delete log data** to remove logging data from the camera's internal memory.

› Acquiring a GPS signal

Once you've enabled GPS your EOS 7D Mark II will begin searching for GPS satellites. As it searches the sky, **GPS** will blink on the top LCD panel (and on the rear LCD if the shooting information screen or Live View is displayed). Once a sufficient number of satellites have been found to acquire reliable GPS data, **GPS** will be displayed constantly (GPS data is acquired even when your camera is switched off, potentially draining the battery before you come to use it again).

GPS isn't infallible and there will be times when a sufficiently strong signal can't be acquired. Moving your camera indoors will block the GPS signal, for example, and even outdoors you may find that moving into woodland or a deep valley can be enough to disrupt the signal.

> **Note:**
> When conditions are optimal, GPS acquisition should take around 30–60 seconds.

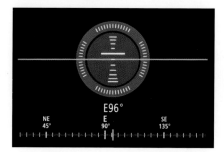

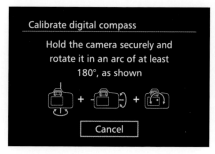

When GPS has been turned on you can also **Enable** a **Digital compass** on the **GPS/digital compass settings** screen. The compass can be used to display a direction arrow in Live View and a compass on the electronic level screen when shooting using the viewfinder.

The first step when the compass has been activated is to calibrate it by selecting **Calibrate digital compass**. Rotate the EOS 7D Mark II as shown by the diagrams on the **Calibrate digital compass** screen. When you've successfully done this, press (SET) to select **OK** and return to the **GPS/digital compass settings** screen.

The digital compass uses the earth's geomagnetism in a similar way to a conventional compass, which means it has some of the same weaknesses. The compass will become more inaccurate the closer you are to a strong magnetic field or when shielded by metal, for example, such as when you are in a car.

Magnetic north and south also aren't the same as true north or south; the Earth's magnetic poles slowly shift as the years pass. This means that the compass shouldn't be used for navigation unless you factor in this difference.

However, what the compass is particularly useful for is judging the direction of sunrise and sunset. The further from the equator you travel, the greater the seasonal variation in the direction that the sun rises and sets. Armed with the knowledge of where the sun will rise or set on a particular day will help you plan and shoot outdoors with greater chance of success.

CONNECTING TO A TV

The EOS 7D Mark II can be connected directly to an HDTV so your images can be seen on a larger screen. Canon doesn't supply the Type C mini-pin HDMI cable necessary to make the connection, but these cables can be found readily in good consumer electronics stores.

Connecting your EOS 7D Mark II to an HDTV TV

1) Ensure that both your camera and TV are switched off.

2) Open the EOS 7D Mark II's rear terminal cover and connect the HDMI cable plug to the HDMI OUT port.

3) Plug the other end of the HDMI cable into a free slot on your TV.

4) Turn on your TV and switch to the correct channel for external devices.

5) Turn on your EOS 7D Mark II. Press ▶ on your camera to view your images on the HDTV.

6) When finished, turn off the camera and TV before disconnecting.

› HDMI TV remote control

If your TV is compatible with the HDMI CEC standard you can use the TV's remote control to control the playback function on your EOS 7D Mark II.

1) Follow steps 1–5 (left) to connect your camera to an HDTV.

2) Use the remote's ◄ / ► buttons to select the desired option displayed on the TV. If you select **Return** and then press **Enter** you will be able to use the remote's ◄ / ► buttons to skip through images on your EOS 7D Mark II.

Menu options	
↩	Return
⊞	9 image index
▶🎞	Play movie
⬗	Slide show
INFO.	Show image shooting information
⟳	Rotate

Your EOS 7D Mark II can be connected directly to a ⚡ PictBridge-compatible printer. This means that you can print out images without the need to copy them to a computer first.

The EOS 7D Mark II is supplied with a suitable USB cable, but some printers also have slots for SD memory cards (but typically not CF cards), so you can even bypass using your camera. Both JPEG and Raw files can be printed when the camera is directly connected to a printer, but only JPEGs when a memory card is used.

Connecting to a printer

1) Check that the camera battery is fully charged before starting to print.

2) Ensure that both the camera and printer are switched off. Insert the memory card of images you want to print into the EOS 7D Mark II if it is not already installed.

3) Open the camera's rear terminal cover and connect the supplied USB cable to the ⚡ digital terminal.

4) Connect the cable to the printer, following the instructions in the manual supplied with the printer.

5) Turn on the printer, followed by the camera. Press ▶ on the EOS 7D Mark II. The ⚡ PictBridge icon will be displayed at the top left corner of the rear LCD screen to show that a connection has been made successfully.

6) Navigate to the image you want to print and then press ⑤ET.

7) The print options screen will now appear (see opposite). Set the required options and then select **Print**. Printing should now begin.

8) Repeat steps 6 and 7 to print out additional images.

9) Turn off the EOS 7D Mark II and the printer, and disconnect the USB cable.

CONNECTION «
⚡ makes printing images simple.

Printing effect	Description
On	The print will be made using the printer's standard setup. Automatic correction will be made using the image's shooting metadata (EXIF).
Off	No automatic correction applied.
Vivid	Greens and blues are more saturated.
NR	Image noise reduction is applied before printing.
B/W B/W	Black-and-white image is printed with pure blacks.
B/W Cool tone	Black-and-white image is printed with bluish blacks.
B/W Warm tone	Black-and-white image is printed with yellowish blacks.
Natural	Prints an image with natural colors.
Natural M	Finer control over colors than Natural.
Default	Printer dependant. See your printer's manual for details.
Date & file number imprinting	Choose between overlaying the date, file number, or both on the print.
Copies	Specify the number of prints to made.
Cropping	Allows you to trim and rotate your image before printing.

Paper settings	Description
Paper size	Select the size of the paper loaded in the printer.
Paper type	Select the paper type.
Page layout	Select how the image will look on the printed page.

Page layout	Description
Bordered	The print will be made with white borders.
Borderless	The print will go to the edge of the page if your printer supports this facility.
Bordered 🛈	Shooting information will be imprinted on the border of prints that are 9 x 13cm or larger.
xx-up	Print 2, 4, 8, 9, 16, or 20 images on a single page.
20-up 🛈 35-up	20 or 35 images will be printed as thumbnails on A4- or Letter-sized paper. 20-up 🛈 adds shooting information.
Default	Your printer's default settings will be used.

Another way to prepare your (JPEG only) images for printing is to use DPOF (or Digital Print Order Format). DPOF is a standard data format that can be read and used by a compatible printer or third-party photographic printing service. The data specifies which images on the memory card should be printed, how many prints of each image should be printed, and whether the shooting date or the file name should be overlaid on the image.

Once DPOF instructions have been added to the memory card you either plug the memory card directly into a compatible printer or take it to your photographic printing service.

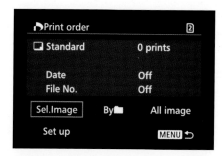

Setting DPOF

1) Select **Print order** on the ▶1 menu, followed by **Set up**. Set the **Print type** (select **Standard** for a normal print, **Index** for a sheet of thumbnails, or **Both**).

2) Set **Date** to **On** if you want the shooting date to be imprinted on your prints, or **Off** if you don't.

3) Set **File no.** to **On** for the image file number to be imprinted on your prints, or **Off** if you don't want this.

4) Press MENU to return to the Print order menu screen.

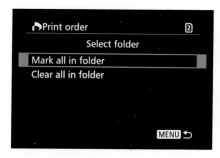

Marking all images in a folder for printing

1) Select **By** ▆ on the Print order screen.

2) Select **Mark all in folder**. Choose the required folder and then press **OK**. A print order for one copy of each compatible image in the folder will be set.

3) To clear the print order, choose **Clear all in folder**, select the folder, then click **OK**.

Marking all images for printing

1) Open the Print order screen and select **All image**.

2) Select **Mark all on card**, followed by **OK**. A print order will be set for one copy of each compatible image on the memory card.

3) To clear the print order select **Clear all on card** followed by **OK**.

Print ordering individual images

1) Open the Print order screen and choose **Sel. Image**.

2) Turn ⊙ to skip between the images on the memory card. Press ⚲ and turn ⚙ counterclockwise to see three images on screen, or clockwise to magnify the current image.

3) If you selected **Standard** as your **Print type**, press (SET) followed by ▲ / ▼ to set

the number of prints to be made from the currently displayed/highlighted image. Press (SET) again to exit and return to normal image view.

4) If you select **Index** as your **Print type**, press (SET) to add the currently displayed/highlighted image to the DPOF instructions to be printed in Index form. A ✓ indicates that the image has been selected—press (SET) to deselect it.

5) Repeat the process from step 2 to add additional images to the print order and then press MENU to return to the main Print order screen.

Direct printing

If your EOS 7D Mark II is connected to a PictBridge printer, highlight **Print** on the Print order menu screen and press (SET). Follow the on-screen instructions, select **OK**, and the printer will print according to the DPOF instructions you've set.

» GLOSSARY

Aberration An imperfection in a photograph, usually caused by the optics of a lens.

AEL (automatic exposure lock) A camera control that locks in the exposure value, allowing a scene to be recomposed.

Angle of view The area of a scene that a lens takes in, measured in degrees.

Aperture The opening in a camera lens through which light passes to expose the sensor. The relative size of the aperture is denoted by f-stops.

Autofocus (AF) A reliable through-the-lens focusing system allowing accurate focus without the photographer manually turning the lens.

Bracketing Taking a series of identical pictures, changing only the exposure, usually in ⅓-, ½-, or 1-stop increments.

Buffer The in-camera memory of a digital camera, which is used to store image data temporarily.

Center-weighted metering A metering pattern that determines the exposure by placing importance on the lightmeter reading at the center of the frame.

Chromatic aberration The inability of a lens to bring spectrum colors into focus at a single point.

CMOS (Complementary Metal Oxide Semiconductor) A type of imaging sensor, consisting of a grid of light-sensitive cells. The more cells, the greater the number of pixels and the higher the resolution of the final image.

Color temperature The color of a light source expressed in degrees Kelvin (K).

Compression The process by which digital files are reduced in size. Compression can retain all the information in the file ("lossless compression"), or lose data, usually in the form of fine detail for greater levels of file-size reduction ("lossy compression").

Contrast The range between the highlight and shadow areas of a photo, or a marked difference in illumination between colors or adjacent areas.

Depth of field (DOF) This is controlled primarily by the aperture: the smaller the aperture, the greater the depth of field.

Diopter Unit expressing the power of a lens.

dpi (dots per inch) Measure of the resolution of a printer or scanner. The more dots per inch, the higher the resolution.

DPOF Digital Print Order Format.

Dynamic range The ability of the camera's sensor to capture a full range of shadows and highlights.

Evaluative metering A metering system where light reflected from several subject areas is calculated based on algorithms.

Exposure The amount of light allowed to hit the digital sensor, controlled by aperture, shutter speed, and ISO. Also, the act of taking a photograph, as in "making an exposure."

Exposure compensation A control that allows intentional over- or underexposure.

Fill-in flash Flash combined with daylight in an exposure. Used with naturally backlit or harshly side-lit or top-lit subjects to prevent silhouettes forming, or to add extra light to the shadow areas of a well-lit scene.

Filter A piece of colored or coated glass, or plastic, placed in front of the lens.

Focal length The distance, usually in millimeters, from the optical center point of a lens to its focal point.

fps (frames per second) A measure of the time needed for a digital camera to process one photograph and be ready to shoot the next.

f-stop Number assigned to a particular lens aperture. Wide apertures are denoted by small numbers (such as f/1.8 and f/2.8), while small apertures are denoted by large numbers (such as f/16 and f/22).

HDMI High Definition Multimedia Interface.

HDR (High Dynamic Range) A technique that increases the dynamic range of a photograph by merging several shots taken with different exposure settings.

Histogram A graph representing the distribution of tones in a photograph.

Hotshoe An accessory shoe with electrical contacts that allows synchronization between a camera and a flash.

Hotspot A light area with a loss of detail in the highlights. This is a common problem in flash photography.

Incident-light reading Meter reading based on the amount of light falling onto the subject.

Interpolation A method of increasing the file size of a digital photograph by adding pixels, thereby increasing its resolution.

ISO The sensitivity of the digital sensor measured in terms equivalent to the ISO rating of a film.

JPEG (Joint Photographic Experts Group) JPEG compression can reduce file sizes to about 5% of their original size, but uses a lossy compression system that degrades image quality.

LCD (Liquid crystal display) The flat screen on a digital camera that allows the user to preview digital photographs.

Macro A term used to describe close focusing and the close-focusing ability of a lens.

Megapixel One million pixels is equal to one megapixel.

Memory card A removable storage device for digital cameras.

Noise Interference visible in a digital image caused by stray electrical signals during exposure.

PictBridge The industry standard for sending information directly from a camera to a printer, without the need for a computer.

Pixel Short for "picture element"—the smallest bit of information in a digital photograph.

Predictive autofocus An AF system that can continuously track a moving subject.

Raw The file format in which the raw data from the sensor is stored without permanent alteration being made.

Red-eye reduction A system that causes the pupils of a subject's eyes to shrink, by shining a light prior to taking the main flash picture.

Remote switch A device used to trigger the shutter of the camera from a distance, to help minimize camera shake. Also known as a "cable release" or "remote release."

Resolution The number of pixels used to capture or display a photo.

RGB (red, green, blue) Computers and other digital devices understand color information as combinations of red, green, and blue.

Rule of thirds A rule of composition that places the key elements of a picture at points along imagined lines that divide the frame into thirds, both vertically and horizontally.

Shutter The mechanism that controls the amount of light reaching the sensor, by opening and closing.

Spot metering A metering pattern that places importance on the intensity of light reflected by a very small portion of the scene, either at the center of the frame or linked to a focus point.

Teleconverter A supplementary lens that is fitted between the camera body and lens, increasing its effective focal length.

Telephoto A lens with a large focal length and a narrow angle of view.

TIFF (Tagged Image File Format) A universal file format supported by virtually all relevant software applications. TIFFs are uncompressed digital files.

TTL (through the lens) metering A metering system built into the camera that measures light passing through the lens at the time of shooting.

USB (universal serial bus) A data transfer standard, used by the Canon EOS 7D Mark II (and most other cameras) when connecting to a computer.

Viewfinder An optical system used for composing and sometimes for focusing the subject.

White balance A function that allows the correct color balance to be recorded for any given lighting situation.

Wide-angle lens A lens with a short focal length and, consequently, a wide angle of view.

→ USEFUL WEB SITES

CANON

Canon Worldwide
www.canon.com

Canon US
www.usa.canon.com

Canon UK
www.canon.co.uk

Canon Europe
www.canon-europe.com

Canon Middle East
www.canon-me.com

Canon Oceania
www.canon.com.au

GENERAL

David Taylor
Landscape and travel photography
www.davidtaylorphotography.co.uk

Digital Photography Review
Camera and lens review site
www.dpreview.com

Photonet
Photography discussion forum
www.photo.net

EQUIPMENT

Adobe
Image-editing software (Photoshop,
Photoshop Elements, and Lightroom)
www.adobe.com

Apple
Hardware and software manufacturer
www.apple.com

Sigma
Third-party lens manufacturer
www.sigma-photo.com

Tamron
Third-party lens manufacturer
www.tamron.com

Tokina
Third-party lens manufacturer
www.tokinalens.com

PHOTOGRAPHY PUBLICATIONS

**Photography books &
Expanded Camera Guides**
www.ammonitepress.com

Black & White Photography magazine
Outdoor Photography magazine
www.thegmcgroup.com

» INDEX

CANON EOS 7D MARK II
THE EXPANDED GUIDE

FRONT OF CAMERA

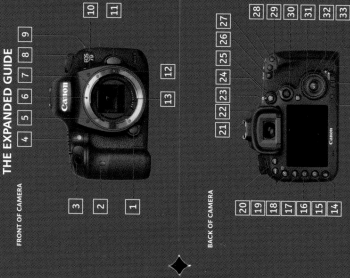

BACK OF CAMERA

1 Depth of field preview button
2 Remote control sensor
3 Shutter-release button
4 Self-timer lamp
5 Reflex mirror
6 EF lens mount index
7 EF-S lens mount index
8 Microphone
9 Left strap mount
10 Flash-release button

11 Lens-release button
12 Lens lock pin
13 Lens electrical contacts

14 Delete button
15 Playback button
16 Index/Magnify/Reduce
17 RATE button
18 Creative Photo/ Comparative Playback
19 MENU button
20 INFO. button
21 Diopter adjustment wheel
22 Movie shooting index mark
23 Still image index mark
24 Live View/Movie shooting
25 START/STOP button

26 AF-ON button
27 AE lock button
28 AF-point selection
29 AF area selection lever
30 Multi-controller
31 Quick control button
32 Quick control dial
33 Touch pad
34 Setting button
35 Access lamp
36 Multi-function lock switch
37 Ambient light sensor

TOP OF CAMERA

38 Mode dial
39 Mode dial lock button
40 Mode dial index mark
41 Built-in flash
42 Top panel LCD
43 Multi-fuction button
44 Main dial
45 Top LCD illumination button
46 Flash compensation/ISO button
47 Drive/AF mode button

LEFT SIDE

48 White balance/Metering mode button
49 Focal plane mark
50 Flash hot shoe
51 ON/OFF switch
52 External microphone terminal
53 Digital terminal
54 Headphone socket
55 Flash PC terminal
56 HDMI out terminal
57 Remote release terminal

BOTTOM OF CAMERA

58 Tripod socket
59 Serial number
60 Information panel
61 Battery cover lock release
62 Battery cover
63 DC coupler slot
64 Right strap mount
65 Memory card cover

RIGHT SIDE